101 MIXED MEDIA TECHNIQUES

MASTER THE FUNDAMENTAL CONCEPTS OF MIXED MEDIA ART

T0125624

**Isaac Anderson, Cherril Doty,
Samantha Kira Harding,
Jennifer McCully, Suzette Rosenthal,
and Linda Robertson Womack**

Brimming with creative inspiration, how-to projects, and useful information to enrich your everyday life, Quarto Knows is a favorite destination for those pursuing their interests and passions. Visit our site and dig deeper with our books into your area of interest: Quarto Creates, Quarto Cooks, Quarto Homes, Quarto Lives, Quarto Drives, Quarto Explores, Quarto Gifts, or Quarto Kids.

ISBN: 978-1-63322-693-7

Printed in China
10 9 8 7 6 5

Table of Contents

Introduction

There are no mistakes in art. Everyone has his or her own creative vision—artful ideas and ways of exploring, discovering, and interpreting. Creating mixed media art allows us to express creativity in ways that evolve right before our very eyes.

Being a mixed media artist allows me to constantly be an explorer, a finder of texture and color, and a queen of chaos—through layers and layers of paint, paper, gesso, and possibilities. Mixed media art offers each and every one of us, regardless of artistic experience, the ability to discover something new with every work of art. Adding a new piece of paper, creating texture with molding paste, or applying gesso to cover an area all help create a masterpiece, no matter how we execute the techniques. There is no right or wrong way to create mixed media art. It is a "zero-experience-needed" art form that colorful souls thrive upon. There are no limits, no rules. There is no right or wrong way to explore.

Mixed media art is about trial and error, passion and purpose, imagining and discovering. This style of art allows artists of all ages to create, using tools and supplies they can find just about anywhere… or might already have on hand. Simply trying different techniques

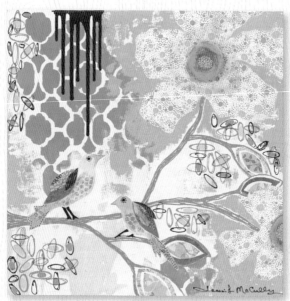

and mediums helps you discover what works and what doesn't. Having fun is a must! Find out what makes you "ooh" and "ahh!" You have the freedom to create as you wish and to explore as you choose, and you will learn so much along the way.

So go ahead—unleash the explorer in you. Be bold. Be brave. Be fearless. Live artfully!

–Jennifer McCully

How to Use This Book

This book includes instructions and inspiration for more than 101 mixed media techniques. You can use these techniques individually or combine as many as you wish in your mixed media art.

Each section outlines the materials you'll need for the techniques included. Due to the flexible nature of mixed media, you don't necessarily need each item listed. Review the techniques before you get started to ensure you have the appropriate materials.

There are 11 different sections of techniques. You can mix and match from any of these sections to create a unique work of art:

Painting Backgrounds

Gesso & Mediums

Art Journaling

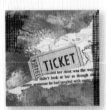
Found & Repurposed Materials

Stamping

Stenciling

Altering Photographs

Transferring

Encaustics

Playing with Paper

Adding Texture

Remember that there are no rules in mixed media art. Try these techniques, but don't be afraid to experiment with them—or come up with your own.

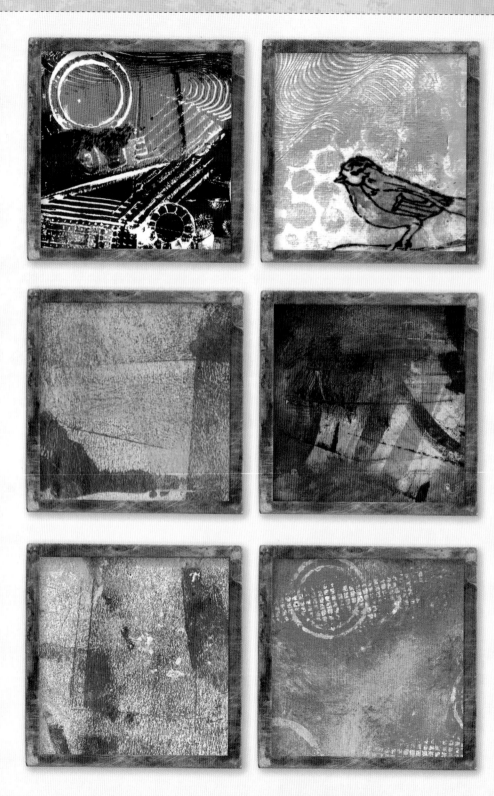

Painting Backgrounds

with Cherril Doty & Suzette Rosenthal

This section features a number of painting techniques that can be used to create backgrounds for your mixed media artwork.

Materials

- Acrylic paints in multiple colors
- Painting surfaces (techniques are demonstrated on mat board and watercolor paper, but they can be applied to almost any surface)
- Old stumpy, splayed brushes
- New 1" soft flat brushes
- Brayer or paint roller
- Old credit card or room key
- Palette knife
- Gelli Arts™ gel plate

Drybrush
Scumbling & Stippling

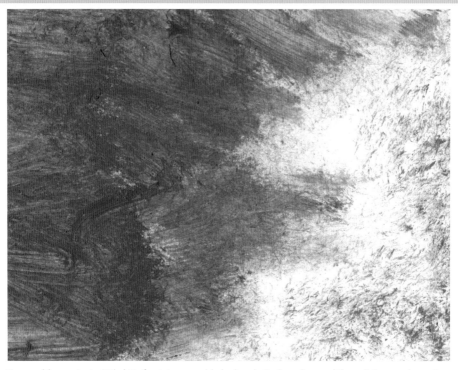

To scumble, use just a little bit of paint on an old, dry brush. Push and spread the paint around, creating a thin layer (left side of image). To stipple, use the same dry brush in a soft bouncing motion, again with a minimum of paint, splaying the bristles as you bounce the brush (right side of image).

Artist Tip
Ask your painting friends to save their old brushes for you, or you can cut down inexpensive brushes to ½ inch—perfect for scumbling and stippling.

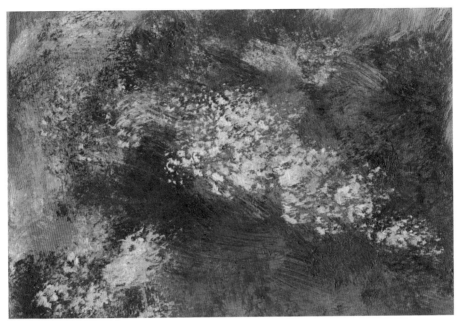

Using scumbling and stippling techniques, mix two or more colors as you move around the surface. There is no need to change brushes, as this creates new and interesting colors as you go. Use white or black to lighten or darken areas as desired.

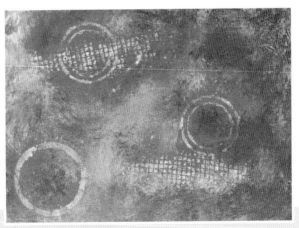

Artist Tip

Use just small amounts of paint in various colors for your palette. You can always add to it if needed! We like to use short, recycled containers with tight-fitting lids so we can save unused paint for another time.

Scraping

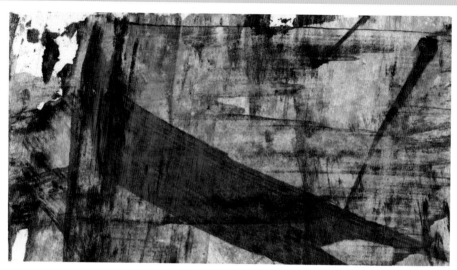

Squeeze two or three colors of paint onto your surface and spread it around by scraping across the surface with a credit card or palette knife.

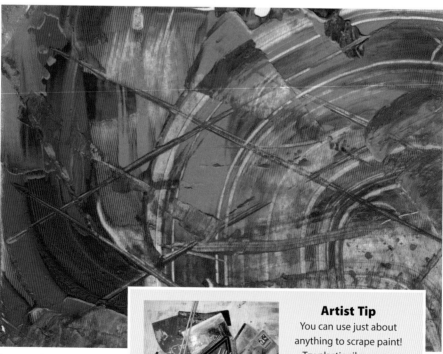

You can also draw lines in your paint with the edge of the card, or push it more to create interesting designs.

Artist Tip
You can use just about anything to scrape paint! Try plastic silverware, combs, skewers, or anything else that can create lines and texture.

Rolling Paint

A brayer is a hand roller typically used in printmaking techniques. Brayers are made of rubber or foam and can be purchased at your local art supply store.

Squeeze a little paint directly onto your surface. Spread the paint with a paint roller or brayer, moving in different directions.

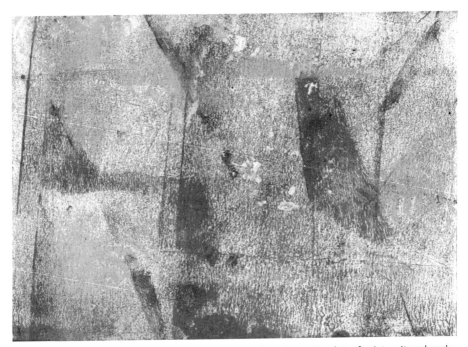

Squeeze paint onto a paper plate. Then roll the brayer in the paint, getting lots of paint on it, and apply using the same technique. Try using several separate colors going in different directions!

Washes

You can use straight transparent colors or add a touch of water over other dry, previously painted surfaces. Use the scumbling technique to tint the colors or papers beneath.

Use water with acrylic paint to create a wash. First mix water and acrylic paint 90/10, and then wash over other colors or papers with a soft brush.

You can use your washes in a variety of ways—as a background or over any of several methods used to create a substrate. The idea is to play with and see what other fun ways you might be able to use this basic technique! You can create a finished piece by stenciling, stamping, and/or drawing over the dry wash and adding focal-point images.

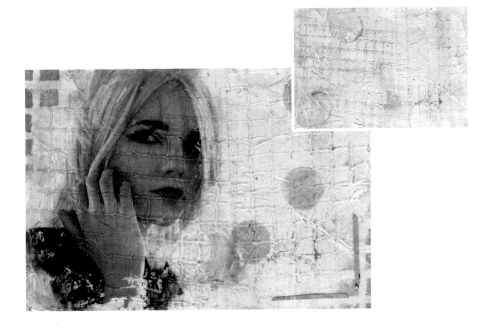

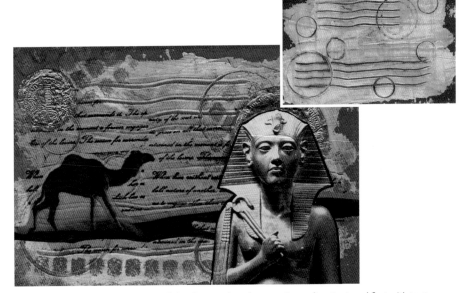

In the two examples above, the wash has been painted over a dry surface textured first with texture paste. Then we added stamping, stenciling, collage, and image transfers to create the finished pieces.

Gel Printing

The Gelli Arts™ Gel Printing Plate has the same sensitive surface as gelatin but is easier to use and store than gelatin printing plates. This printing plate is nonperishable, nontoxic, has a sensitive surface that is always ready for printing, and is easy to clean!

Follow the simple instructions with the Gelli Arts™ gel plate to create interesting painted backgrounds. Spread paint on the plate with a brayer; then draw in the paint or use mark-making tools or stencils to create designs. Lay paper (watercolor paper works great) on the surface. Press down while the paint is wet to impress the image.

You can also create "ghost images" by pressing a second sheet of paper or mat board into the remaining wet paint. The ghost image will be lighter and less intense.

Notice how much texture, dimension, and movement can be created with this one simple technique.

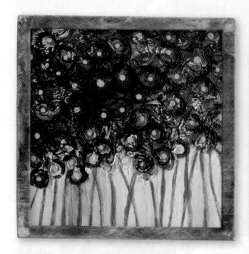

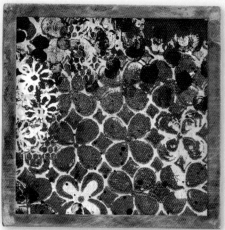

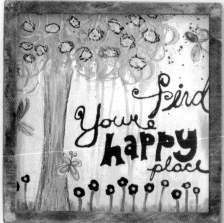

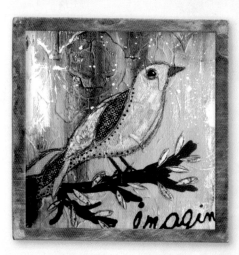

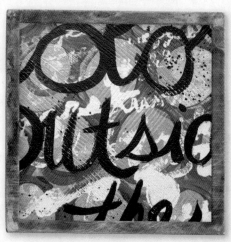

Gesso & Mediums

with Jennifer McCully

Discover techniques for working with gesso and mediums to add texture and dimension to your artwork.

Materials

- Hard molding paste
- Acrylic paints in multiple colors
- Palette knife
- Rubber shaper
- Canvas or wood substrate
- Gel medium (matte) or soft gel medium (matte)
- Photograph or magazine/catalog image
- Old credit card
- Spray water bottle (optional)
- Powdered pigment
- Gesso
- Dry brush
- Spackle (wall putty)
- Stencil or found object
- Paintbrushes
- Glass bead gel
- Pouring medium
- Clear plastic squeeze bottle with tip
- Variety of stamps
- Paper plate
- Squirt tube or bottle (small to medium with a tip)
- Clear tar gel
- Plastic or paper cup
- Found object (such as a wire pet comb, a cleaning brush, etc.)
- Scissors or craft knife
- Wax paper or acrylic board

Creating Shapes with Fiber Paste

Fiber paste is a medium with a dry film that has the appearance of rough, handmade paper. You can skim fiber paste with a wet palette knife to create a smoother surface.

Step One Using a palette knife or spoon, place approximately four to five tablespoons of fiber paste on a sheet of wax paper or an acrylic board and add a small amount of acrylic paint.

Step Two Blend with a palette knife, smoothing the top so there are no peaks. Try to have your fiber paste between ⅛- and ¼-inch thick. Let the fiber paste dry completely.

Step Three You can use additional paint to decorate the fiber paste with spatters, stripes, polka dots, etc. Use your imagination!

Step Four Once dry, lift the fiber paste off the wax paper. Cut it into any shape you desire. Now you can add your mini work of art to a larger mixed media piece!

Creating Texture with Molding Paste & Stamps

Molding paste, which is great for building surfaces and creating texture, dries to a hard, flexible, opaque film.

Step One Apply a thin layer of molding paste with your palette knife over the area you wish to add texture. Using the stamp of your choice, stamp all over the molding paste. You can stamp randomly or in a consistent pattern. I like to use a clear rubber stamp with no wood because it is flexible and I can see where I am stamping.

Step Two Once the molding paste is dry, rub paint over the stamped area, using your fingers or a brush. I like to use my fingers to apply acrylic paint over the textured area because I have more control over the look and feel. For a more textured look, don't try to fill in all the areas.

Step Three You can use this technique as a starting point for a new work of art and simply keep building from there, or you can make the textured area just a small accent piece of a larger work of art.

Artist Tip
If you only want to cover or accent a certain area, you can brush molding paste onto a stamp and only stamp in the desired area. Once completely dry, you can rub ink instead of acrylic paint over the accent areas to add dimension and contrast.

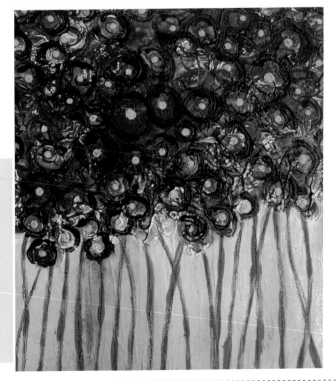

Creating Texture with Gesso & Pouring Medium

Pouring medium allows for even, flowing applications of color without cracking and dries to a high-gloss finish. Once dry, it is flexible, non-yellowing, and water-resistant.

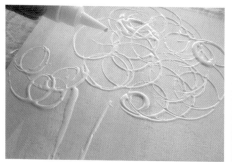

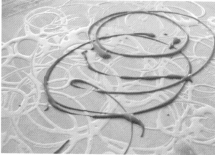

Step One Add one part gesso and one part pouring medium (approximately an ounce or two of each) inside a clean tube. With the cap on, shake the tube until the mixture is blended. Then start drawing on your blank substrate with the squirt tube. You can make random shapes or sketch an object.

Step Two Allow the mixture to dry completely. Then squirt paint colors randomly over the design.

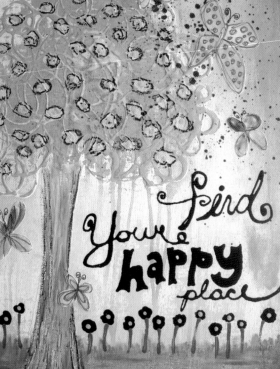

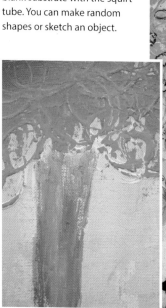

Step Three Use a palette knife, brush, or old credit card to rub the paint over your design, creating texture and dimension.

Step Four You don't have to stay in the lines, and you can add additional dimension by painting other shapes on top of your design.

Creating Texture with Molding Paste & Stencils

Step One Start with a pre-painted canvas or wood substrate. Place your stencil where you want the texture and use a palette knife to add molding paste over the stencil.

Step Two It is not necessary to fill every nook and cranny. Just make sure you can see the basic outline and design of your stencil. Once done, immediately wipe the molding paste off of your stencil.

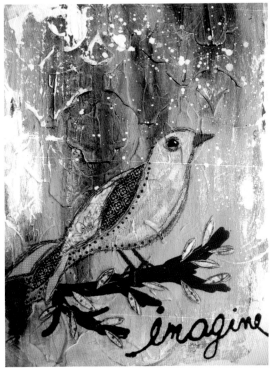

Step Three Allow the molding paste to dry completely. Then start your creative process by adding ink or acrylic paint to the raised part of your art. You can use a palette knife, your fingers, or an old credit card to rub acrylic paint over the pattern.

Image Transfer with Gel Medium

There's no shortage of resources for images to transfer. Your image can come from a magazine, a catalog, or photograph. To print an image, make sure you print from a digital/laser printer, not an inkjet printer.

Step One When making an image transfer, your canvas background can be blank or painted with a light color.

Step Two Cut out the image that you wish to transfer or slightly rip around the edges to give it an "edgy look." Using a dry brush, apply gel medium to the area where you will place the image. Once you have covered the area, lay the image facedown on top of the gel medium. Remember: your image will be reversed once it has been transferred! Flatten the image as much as possible using an old credit card.

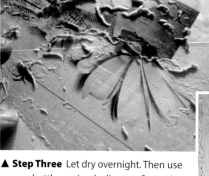

▲ Step Three Let dry overnight. Then use a spray bottle, or simply dip your fingertips in water, to start the process of removing the top layer of paper from the canvas. Work at this process until all the paper is gone and you can see the transferred image. Wipe off any paper shavings as you go. You can use a dry paper towel once all of the wet paper has been removed to rub off any dry "fuzz" from the transfer process. Once all of the paper is removed and your image transfer is dry, you can continue creating the rest of your painting (right)!

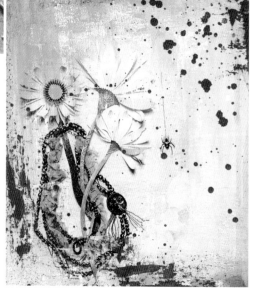

Powdered Pigment & Gesso

When working with powdered pigments and gesso, just think of it as color tinting your gesso!

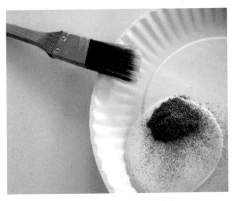

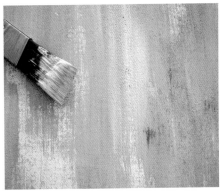

Step One Start by mixing gesso and the powdered pigment together. The pigment is richer in color on its own and will only subtly tint the gesso, giving it a grainy texture.

Step Two Apply to any area of a painting where you want to add texture, or as a background for a new painting.

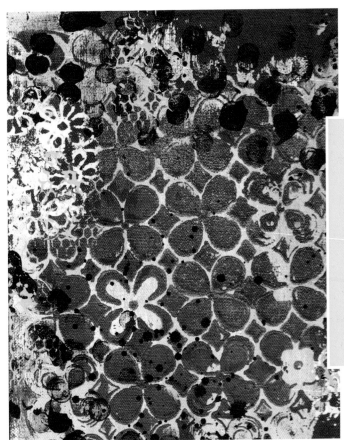

Artist Tip

Once your background is created, sprinkle some of the powdered pigment directly onto your canvas for extra texture and sparkle. Varnish with a non-glossy, matte varnish to keep the added texture in place. Once dry, you can keep building texture or simply make this technique the final step to completing your masterpiece!

Clear Tar Gel & Acrylic Paint

Clear tar gel is designed to create a stringy, tarlike substance. It is great for dripping and drizzling over surfaces and becomes stringier the more you mix it.

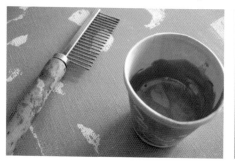

Step One You can add a small amount of acrylic paint directly into your jar of clear tar gel or, if you prefer not to tint the entire jar, pour some clear tar gel into a small cup. Add a small amount of paint to the gel and mix it thoroughly. Some bubbles will appear. Once mixed, close the jar of your tar gel or place your cup into a sealed plastic bag to keep the moisture in the gel. Let stand overnight to get rid of the bubbles.

Step Two Working on a blank or previously painted canvas, pour the tinted gel directly onto your canvas. Or, you can create squiggly lines and shapes with a palette knife by dipping the knife into the mixture and running it over your canvas to drip at random.

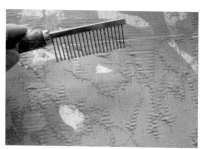

Step Three Immediately after applying the tar gel mixture, go over it with a pet comb or stiff bristle brush.

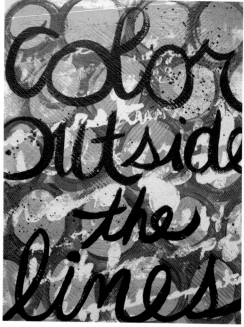

Step Four To add texture and dimension, go over these areas in different, crisscrossing directions.

Step Five Allow the tar gel to dry completely before adding additional color or items to your painting.

Carving with Hard Molding Paste

The key to this technique is the background that you have already created. Whatever your background looks like is what will come through when carving out of hard molding paste.

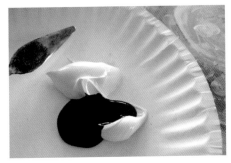

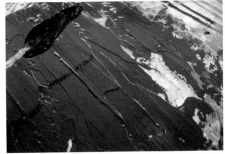

Step One After selecting or preparing your background, start with a small bit of hard molding paste mixed with your color of choice. I'm using black in this example.

Step Two Once mixed, apply the paste to the section of your painting that you wish to "carve out," using a palette knife to smooth out the molding paste as best as possible. Just be careful not to make it too thin.

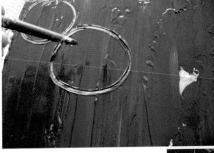

Step Three When you are done applying the paste mixture, use a rubber shaper to carve out any design that you wish—it can even be a shape or word! If you mess up, simply smooth out the molding paste and try again.

Step Four Keep a paper towel on hand to wipe off your rubber shaper throughout this process to keep it nice and pointed for precise shapes and letters. It takes a couple of hours for your molding paste to dry completely, so you have some time to play with your shapes. Once dry, you can leave your piece as is, or you can add more paint.

Glass Bead Gel, Pigment Powder & Acrylic Paint

Combining glass bead gel, pigment powder, and acrylic paint together produces a chunky finish—iridescent even, if you use an iridescent pigment powder. This technique can be used on a small or large scale depending on the type of art you wish to create. I chose to use this technique on a small scale, using a stencil to simply accent a certain part of my artwork.

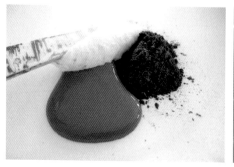

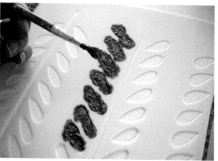

Step One Mix glass bead gel, pigment powder, and acrylic paint together on a paper or acrylic plate. Don't worry about using equal amounts, as it does not affect the outcome much. It is always best to start small and add more as you go if you run out of your mixture.

Step Two Once all three items are blended, apply to your artwork using a brush or a palette knife. I used a stencil to create a leafy pattern.

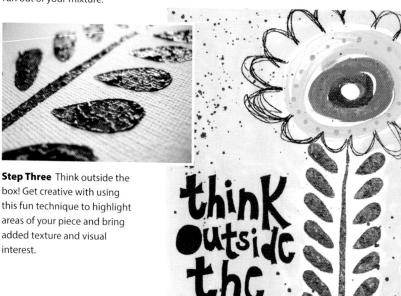

Step Three Think outside the box! Get creative with using this fun technique to highlight areas of your piece and bring added texture and visual interest.

Paint Drips

Paint drips are a fun way to add a finishing touch to your artwork. In this example I simply add paint drips to an already fun and funky background. If your paint is more fluid, use less pouring medium. If your paint is medium-or heavy -bodied, use more pouring medium to thin your paint enough to pour it onto your artwork.

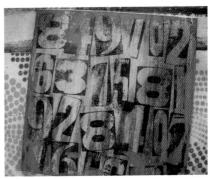

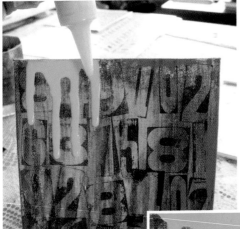

Step One Add a small amount of pouring medium to a clean, clear plastic squeeze bottle with a tip, filling only about a quarter of your bottle. Then add paint, starting small and adding more as needed. Place your finger over the tip and shake vigorously to mix well. When the consistency is right, start adding drips to your artwork.

Artist Tip
Test the pouring thickness on a paper plate to ensure that it has reached the right consistency for dripping. If your mixture is still too thick, simply add more pouring medium, a little at a time. Shake again until well blended. Always test your mixture first before applying to your artwork.

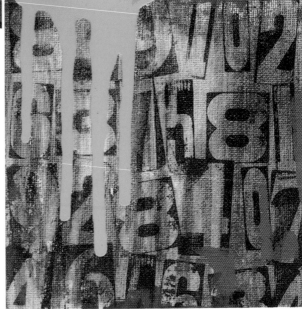

Step Two Once you have added drips and they have reached as far down as you would like them to, lay the art flat and let dry for at least one hour before touching. A longer drying time may be needed, depending on the thickness of your mixture and the amount of area covered.

Spackle with Stencils or Found Objects

Spackle is similar to molding paste, but it dries white. The idea is that you are creating dimension in your artwork! Any type will do—even the kind with sand in it. The spackle I use in this example is the type that goes on tinted (pinkish-purple) and dries white once it is completely dry. This helps you know when it is okay to move to the next step in your creative process.

Step One Since spackle dries white, it's fun to use on a colored background. Once you have your stencil or found object (such as a clean pet comb, sponge, rubber stamp, etc.), place it on the area where you wish to have a pattern. Using your fingers or a palette knife, rub the spackle over the stencil. If you're using a rubber stamp or pet comb, put a layer of spackle on your substrate and run your comb or stamp over it to create a pattern.

Step Two Remove the stencil once you are done and wipe it clean.

Step Three The spackle turns white when it is dry and ready for you to paint or create as you wish!

Glass Bead Gel

Glass bead gel on its own adds unique texture to any artwork.

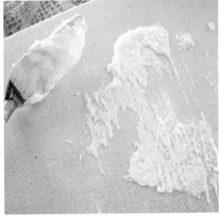

Step One You can start with a blank substrate or have a light color wash as your background before applying the glass bead gel.

Step Two Using a palette knife, apply glass bead gel wherever you wish to add texture to your artwork.

Step Three Once the glass bead gel is completely dry (above left), you can rub watered-down paint across the texture to add dimension to your artwork. You will notice that after additional color is added the glass bead gel creates one-of-a-kind grooves and crevices for paint to settle in (above right, right).

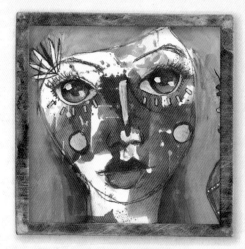

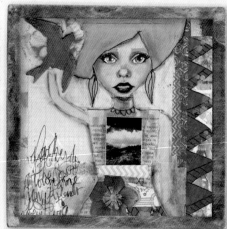
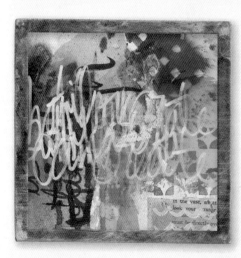
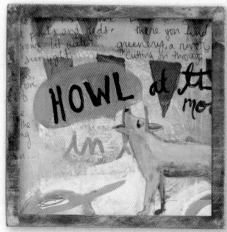

Art Journaling

with Samantha Kira Harding

Art journaling is about layering materials and adding color inside a sketchbook or journal to create a meaningful, personal series of art. The intention behind the pages and the addition of written journaling sets this apart from a traditional sketchbook. In an art journal, you can practice a new skill or use that stash of paint you've held onto. The possibilities for expressing the story of your life and how you see the world are endless! Just dive in and create what brings you joy!

Materials

- Eyedropper
- Watercolor paints
- Inks
- Liquid acrylics
- Spray bottle
- Markers
- Scissors
- Papers and book pages
- Found objects
- Thick pencil
- Molding paste
- Stencils
- Palette knife
- Water-soluble crayons or oil pastels
- Fabric
- Stamps
- Gesso
- Paintbrush
- Glazing medium

Dripping Ink

To create this look, use an eyedropper to add a couple drops of liquid watercolors, inks, or liquid acrylics onto an area of your surface. Then tilt your surface up to let the ink run down. If it doesn't drip the way you'd like use a spray bottle to encourage it.

Artist Tip

Wait between layers of ink to keep it from running together and creating "mud." Liquid watercolors will "open up" if you hit your surface with a spray bottle, so for the best layered look use inks or liquid acrylics.

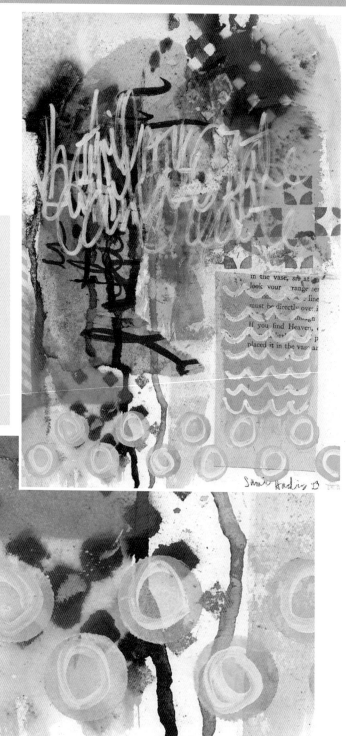

Patchwork Background

Take a piece of scrap paper, old book pages, or scrapbooking paper and write your intention on it with a big marker. Switch colors to make it more dynamic.

Next cut the paper into strips and squares, and then re-assemble them on your surface or page to create a patchwork of paper!

Artist Tip
Use an acrylic glaze or watercolors in a neutral color to tie the patchwork together and make a great base for art journaling.

Stamped Journal Pages

You don't need to go to the art supply store for this technique. Just look around the house for regular objects you can use to stamp and make marks on your surface or page!

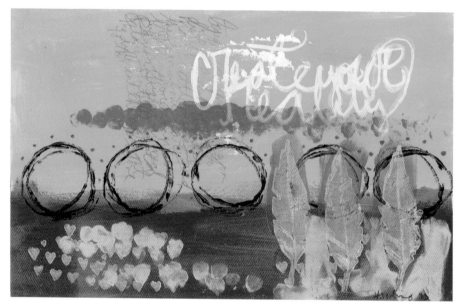

In this example I used a paper towel tube to stamp across this page with blue acrylic paint. You can use sticks, combs, fruits and vegetables, wine corks, and more! Press them into acrylic paint to make marks.

Artist Tip

If you find more absorbent objects around the house, you can make them easier to stamp with by putting a thin layer of gel medium or glue on the surface to get a better impression.

Artist Tip

You can stamp an entire journal page or just part of a page. Try stamping in colors that reflect your mood. For example, use orange, red, and yellow to reflect energy, passion, or anger.

Chunky Drawings

It's easier to draw in your journal when you use a thicker pencil or darker pencil. Remember to keep your marks loose and big. Start with an eye by drawing the basic eye shape and circles in the eyes. A nose can be a simple wavy line. Draw a mouth with just the line where the lips join and some loose outlines. You can make hair as big as you can imagine! Just a few marks can make an expressive face.

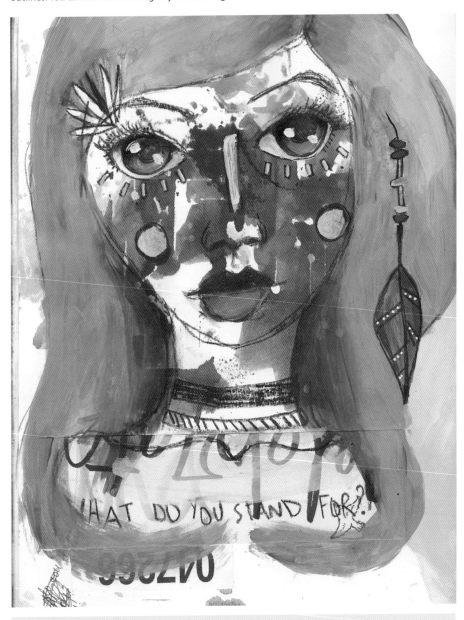

Artist Tip
A little paint can accent features, such as cheeks, lips, eyes, and hair.

Stenciled Pages

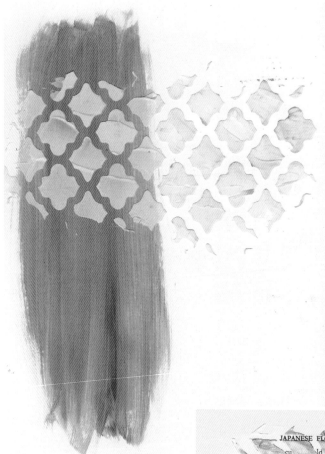

Using a stencil and some molding paste is a great way to add texture to your surface.

Step One Simply put the stencil down on your surface and use a palette knife to spread molding paste through it. Hold the knife at a 45-degree angle to keep the surface flat and even. If you're using a thicker stencil, you'll want to scrape the paste so that it is even with the top of the stencil.

Step Two Pull up the stencil and allow the paste to dry for about a half hour—you can use a heat tool to speed up the process!

Artist Tip
Mix in some paint with the paste to tint it. If you're working in an art journal or with paper, use light molding paste.

Painting with Water-soluble Media

Use media such as water-soluble crayons or oil pastels in place of acrylic paint to achieve a different look and add texture. The color is only as consistent as the amount of each media you put down, allowing you to create uneven but beautiful areas of paint and blend colors right on your surface.

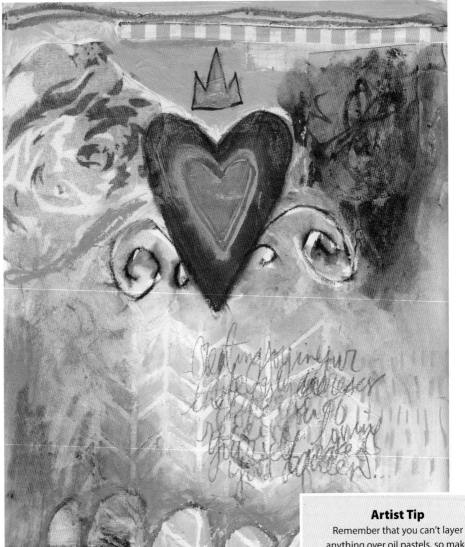

Color or scribble in areas that need a touch of color, then apply a wet brush or water brush to move the color around. Experiment with little or a lot of water to achieve different looks, such as smudged color or a wash.

Artist Tip
Remember that you can't layer anything over oil pastels, so make those your final, top layer over any water-soluble based media. Investing in media with a higher pigment load will mean using less of the crayons to cover larger areas, so your supplies will last longer.

Dyeing & Stamping Fabric

Just because you're working in an art journal or on a canvas doesn't mean you can't utilize fabric as a collage element.

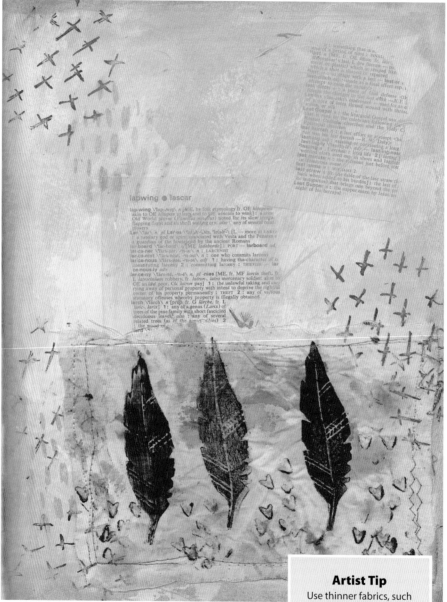

Use liquid watercolors, spray inks, or liquid acrylics to drip on or paint fabric, creating a colorful surface to stamp on with your choice of ink. Layer stamps to create texture. If your journal is large enough, you can use a sewing machine to attach the fabric to a page in your journal, or you can hand-sew it to a canvas.

Artist Tip

Use thinner fabrics, such as muslin, as a clean-up rag in your studio. When it's sufficiently covered in paint, you can cut it up and use it in your journal or other projects.

Gesso Overpainting

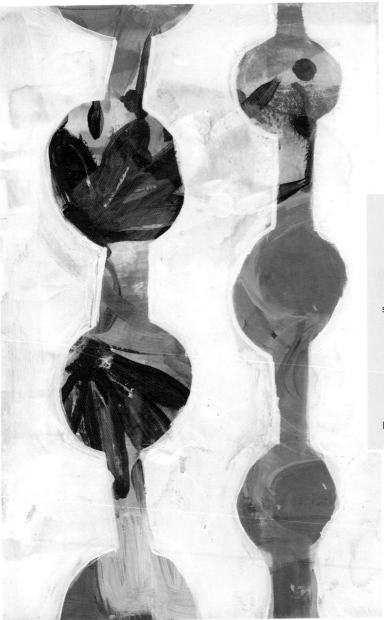

Artist Tip

This is a great way to "save" a page or painting you don't like. Find the areas you love and draw shapes around them. Then paint over the rest with gesso. You can use a couple of coats to keep the background from showing through. Then add more layers or leave it as is!

Start with a blank page or surface. Use your favorite media to add splashes of color, doodle with paint, or create a fun abstract background. Use a round brush to draw shapes with gesso, circle areas you like, or create a pattern. Overpaint the background so it only shows through the holes in your pattern. Continue to add layers or leave it as-is for a fun, easy page! Depending on how many coats of gesso you use, certain parts of the background will be visible through the gesso.

Altered Handwriting

Use a brush or pen to write across a page or add notes, a journal entry, or lyrics. Look at the artwork of those you admire or handwritten advertisements for inspiration, and begin altering your handwriting to create a new look.

Using a round brush, write large letters across your surface with acrylic paint or india ink. Add glazing medium to loosen up heavy-bodied paints. Go over the letters a couple of times.

Paint around your handwriting to make it pop!

Artist Tip
This technique works best with fluid acrylics or paint that has a bit more flow, as you can more easily glide across your surface.

Scrap Mini Collages

As an artist you begin to collect and keep scrap papers—remnants after cutting papers down for a larger collage, interesting photos, or even parking receipts! A fun way to use them is to create a mini collage inside of a dress, silhouette shape, or tag you can glue onto a page or painting.

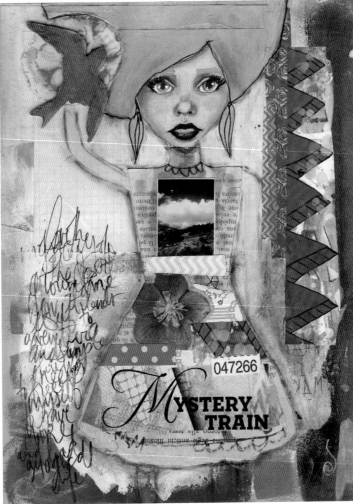

Start with a couple focal pieces that are larger than the rest. Then search through your stash for pieces that will fit around the focal pieces. Continue until the shape or tag is covered.

Artist Tip

Find or buy a little bin or box to keep on your desk. Every time you cut something down or find a scrap in your bag, toss it in the box. Then you'll have tons of collage fodder at your fingertips!

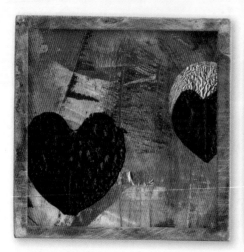

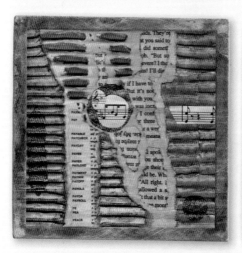

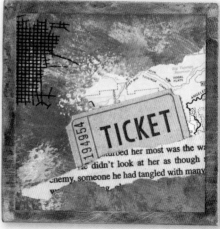

Found & Repurposed Materials

with Cherril Doty & Suzette Rosenthal

"Upcycling" is taking something disposable and turning it into something of greater use and value— in this case, art. While we use found and repurposed materials in a number of ways—both as tools to create art and as part of the art itself—upcycling properly refers to the art pieces created this way, while recycling refers more to use of these objects again and again to create.

Materials

- Printed mailers
- Cardboard (from cartons, cereal boxes, etc.)
- Multiple found objects
- Gesso
- Sandpaper
- Soft wide brush
- Acrylic gel (matte or gloss)
- Acrylic medium (matte or gloss)
- Candy foils
- Stencil
- Nevr-Dull®
- White glue

Upcycling Printed Mailers & Cardboard

Postcards, bi-folds, tri-folds, and other mailers that arrive in your mailbox make excellent substrates for your artwork.

Step One Sand the mailers lightly on both sides. Then, with a paintbrush, coat each side with gesso, letting one side dry before doing the other.

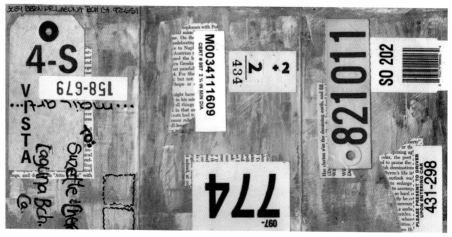

Step Two Once dry, you have a surface upon which to paint, collage, write, do mark-making, or whatever other techniques you desire! Try using other found papers or materials.

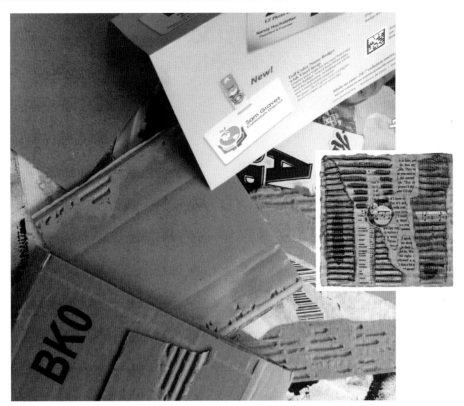

These boxes, inserts, and other cardboard materials can also be used as a substrate when prepared. For corrugated cardboard boxes, rip away sections of the paper surface to expose the corrugation. You can adhere other torn-off corrugated pieces for texture. Paint a coat of gesso on the cardboard and then use as desired. If printed, as with cereal boxes, sand lightly before applying the gesso. You can also tear edges for an interesting effect (see inset).

Easy Collage Technique

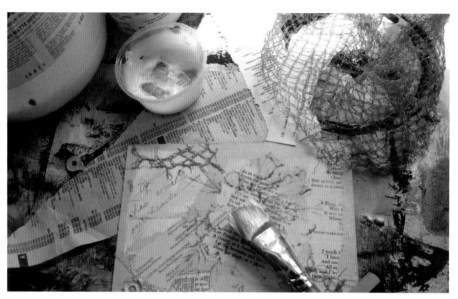

Step One For lightweight papers and other ephemera, use a wide brush to spread liquid acrylic medium (matte or gloss) on your substrate.

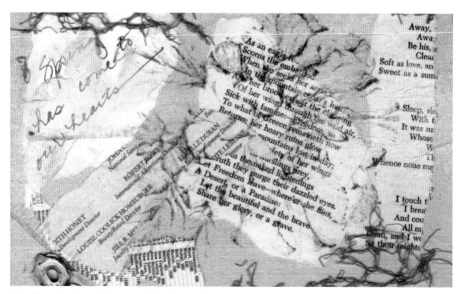

Step Two Lay down the material on the medium and use the brush to spread a coat of medium over the top, smoothing papers down.

Artist Tip
For heavier papers and other items, use acrylic gel in the same manner.

Using Organic Matter

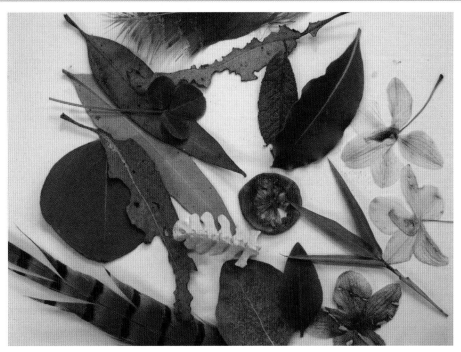

Step One Look for things that will make a focal point or add interest to your piece. Leaves, pressed flowers, feathers, and other found organic items can add natural texture to mixed media.

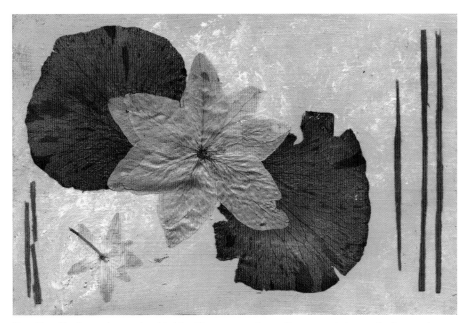

Step Two Use items that can be dried flat. Then use acrylic medium to apply to your background. Some items will become transparent, while others remain opaque.

Using Man-made Found Objects

Use man-made found objects, such as pieces of screen, broken glass, plastic bits, tickets, stubs, maps, and security envelopes to create interesting backgrounds or focal points.

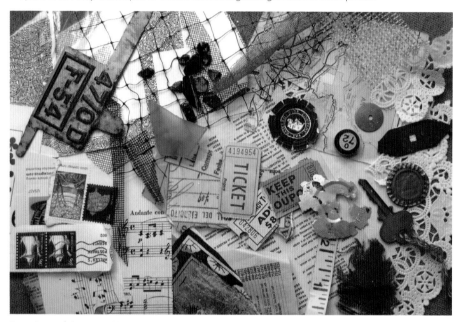

Step One Gather items like ticket stubs and parking vouchers to create great focal points.

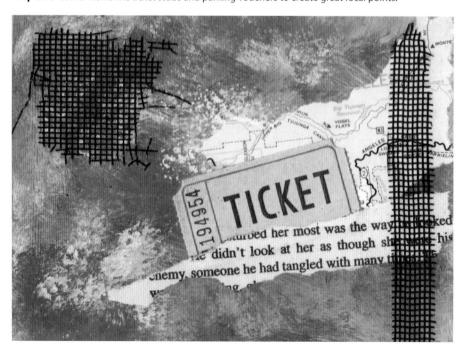

Step Two Apply found objects to your background using acrylic medium or gel.

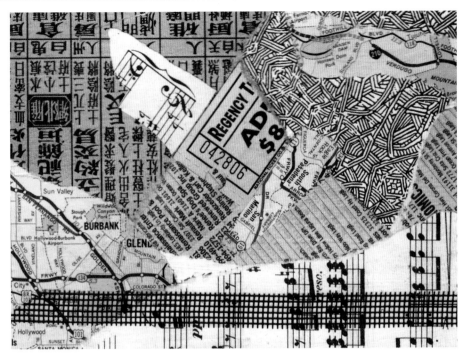

Step Three One of our favorite techniques is to use high-contrast papers, such as sheet music, security envelopes, and book pages. Tear papers and adhere to your substrate with acrylic medium.

Step Four Paint over these pieces using scumbling or an acrylic wash. The pieces show through for an interesting background effect.

Candy Foils

Candy foils are a fun way to add shine to a piece or spotlight a focal point. Just think—you get to eat the chocolate first!

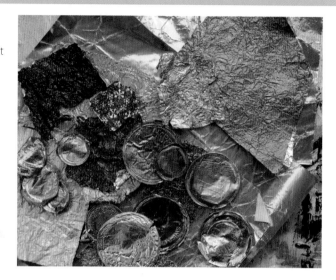

Step One First clean your empty candy foils of all chocolate. You can use them smoothed or crumpled for a bit of texture.

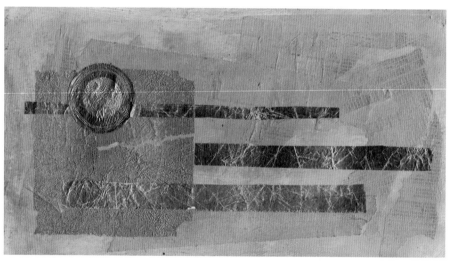

Step Two Adhere foils with gloss gel medium, which can also be applied over the foils. (For more re-purposed paper goods, please refer to pages 113–121.)

Artist Tip
Gloss gel medium dries to a glossy, transparent finish. You can also use this medium to increase the brilliance and transparency of color without changing the thickness of the paint. Give it a try!

Nevr-Dull®

Nevr-Dull® is specially-treated cotton wadding generally used for cleaning and polishing metal. It also removes the ink and toner from magazine pages.

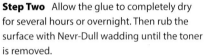

Step One Adhere a portion of a magazine page to your mat board substrate by coating the board with acrylic gel. Then smooth the magazine onto the surface with a brayer, being careful not to get gel on the surface. Once dry, place a stencil on top and carefully paint white glue in the stencil spaces. Lift off the stencil and wash it immediately.

Step Two Allow the glue to completely dry for several hours or overnight. Then rub the surface with Nevr-Dull wadding until the toner is removed.

Step Three Voilà! You now have a unique background with which to work.

Stamping

with Cherril Doty & Suzette Rosenthal

We use stamping techniques extensively to create interest and variety in our backgrounds. There are a multitude of ways to use stamping. This section shows some of our favorites.

Materials

- Purchased rubber stamps
- Corks, tape spools, coffee cup sleeves, bubble wrap, and other man-made objects
- Leaves, seedpods, shells, and other organic objects
- Sandpaper
- Erasers (dense, polymer works best)
- Man-made and natural sponges
- Children's foam blocks
- Rubber bands, paper clips, wire, etc.
- Pipe insulation foam for ¾" pipe
- 1" diameter wood dowel
- Wood burning tool or soldering tool
- Heat tool for embossing
- Craft knife or other carving tools
- Waterproof inkpads
- Acrylic paints
- Paintbrushes
- Brayer
- Tissue paper, sewing pattern paper
- Prepared substrates

Note: It is extremely important to clean your stamping tools with soap and water immediately after use, so that paint or ink does not dry on them.

Stamping with Acrylic Paint

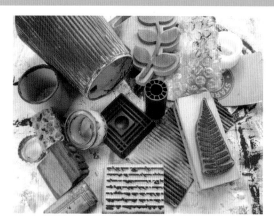

When it comes to stamping, you can use readily available purchased rubber stamps or a variety of man-made found objects. We especially like the effect of a variety of tape spools, coffee cup sleeves, wine corks, and bubble wrap—objects you might use for this technique are limited only by the imagination!

With a paintbrush, brush a small amount of paint on your rubber stamp and press down on your previously painted substrate. Notice how this technique leaves a much different impression than an inked stamp would!

Artist Tip

Use a large piece of cardboard as a place mat beneath your work-in-progress. You can also use it as a palette and to test color; check the amount of paint on your brush; and experiment with your stamps before stamping on your piece.

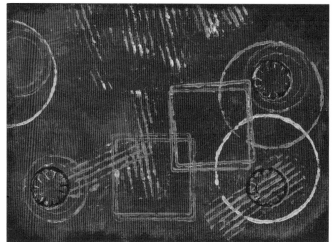

Use the same technique when stamping with man-made found objects, and apply a small amount of paint to your object with a paintbrush. Make sure you wash your tools immediately after stamping!

Stamping with Natural Objects

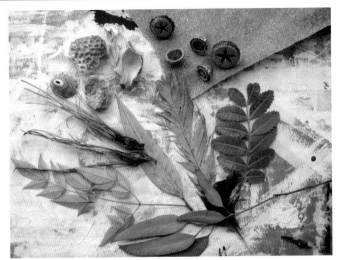

You can also use natural objects as stamps, such as leaves, seedpods, shells, and feathers. Flattened objects will work best.

Brush a small amount of paint onto the object and press it on the substrate. You can use a brayer with flat objects to achieve a more crisp impression.

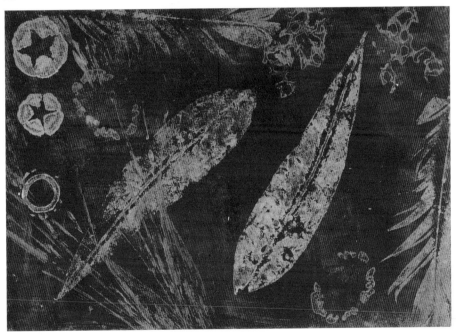

Next time you visit your local park or walking trail, bring a large envelope or a plastic bag to collect natural objects you can use in your mixed media projects. Remember to respect the environment, and don't collect items from protected areas!

Carving Your Own Stamps

You can create custom stamps by carving corks and erasers. You can do this freehand or make a template, lay it on the surface, cut around it, and carve, adding details after you remove the template.

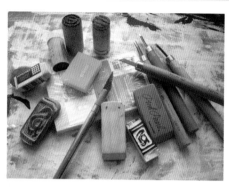

Treat your carved stamps like you would any other. You can brush on a bit of acrylic paint, or you can use an inkpad. Make sure you clean your stamp before the paint or ink dries.

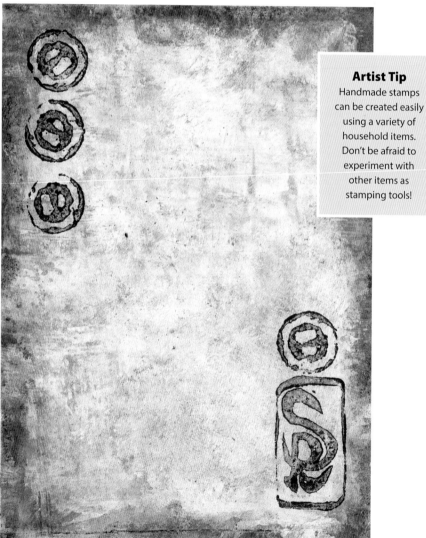

Artist Tip
Handmade stamps can be created easily using a variety of household items. Don't be afraid to experiment with other items as stamping tools!

Stamping with Sponges

Keep a collection of both man-made and natural sponges on hand for stamping.

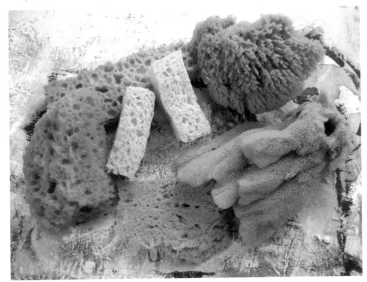

To stamp with a sponge, first lightly spritz with water. Then dab a small amount of paint onto the damp sponge with a paintbrush and stamp onto your substrate.

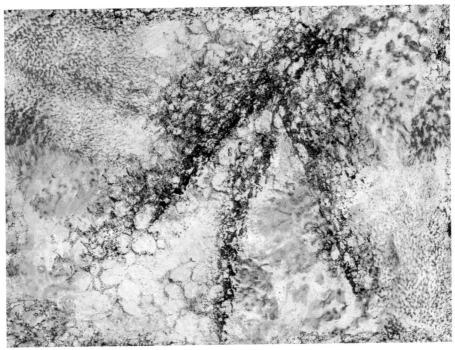

Artist Tip

If some areas don't show up well or you're not happy with the look after you've lifted your stamp, try stamping more on top.

Making Unique Stamps

To make a rolling stamp, use a craft knife to cut pipe insulation foam to the desired length. Insert a wood dowel into the center of the foam. Use a wood burning or soldering tool to cut a design around the foam, barely touching the tip of the tool to the foam. Make sure you work in a well-ventilated area. To use, paint the surface of the foam and roll the dowel across the paper.

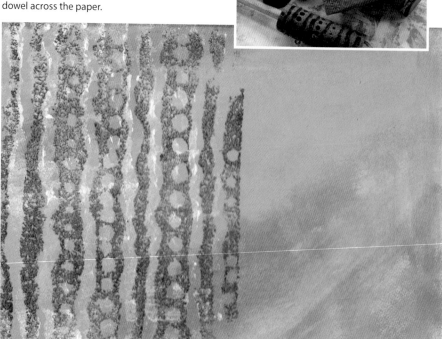

Try making another kind of stamp using colorful children's foam blocks. They are easily found at thrift stores—and all four sides can be used! You can use objects such as pins, paper clips, washers, and buttons to imprint your foam. Spread the objects out on your work surface. Then heat the foam on one side, using the heat tool, for 10-15 seconds. Press the heated side into the object to get an imprint. Use these stamps with waterproof inkpads or acrylic paint. Note that paint makes the foam brittle over time.

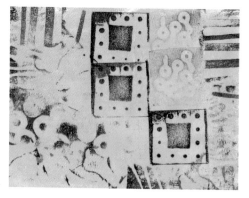

Artist Tip
Instead of imprinting the foam blocks, try wrapping them with rubber bands, wire, hair bands, twine, etc. and stamping with waterproof inkpads.

Stamping on Tissue Paper

Tissue paper and sewing pattern paper are great for stamping with any of the techniques in this section.

You can tear tissue paper or apply it whole to your substrate, using acrylic medium.

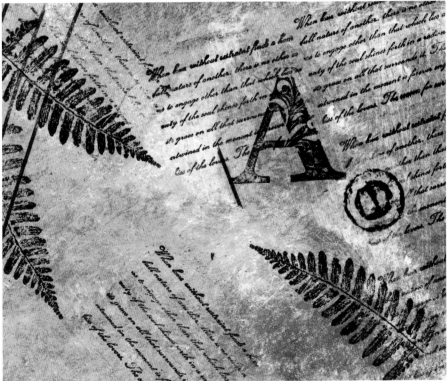

Artist Tip

With many of these techniques, it is fun and interesting to try a variety of colors using the same image in a repeat pattern. Also, do not forget the use of repeat "ghost" images of the same color in one piece!

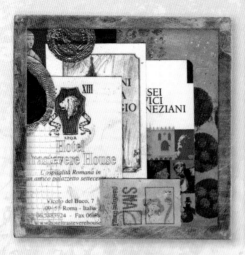
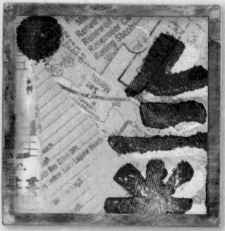
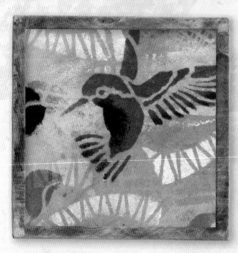

Stenciling

with Cherril Doty & Suzette Rosenthal

When stamping, we use the tool—the stamp—to apply paint or ink. When stenciling, however, we use a blunt, short-bristled brush to force the paint through the tool—the stencil! As with stamping techniques, it is always important to clean your stencil—especially the purchased ones—immediately to prolong the use of the tool.

Materials

- Blunt, short-bristled brushes
- Acrylic paint, medium, and gel
- Glue stick
- Mr. Clean® Magic Eraser® or equivalent
- Waterproof inkpads
- Purchased stencils, including letters/numbers
- Sequin waste (punchanella)
- Plastic fruit baskets
- Mesh produce bags
- Doilies and openwork place mats
- Drywall tape
- Hole-punched papers
- Die-cut papers for scrapbooking
- Paper or painted substrates

Drybrush Bouncing

With a small amount of paint on a short-bristled brush, bounce the brush over the stencil opening, forcing the paint through.

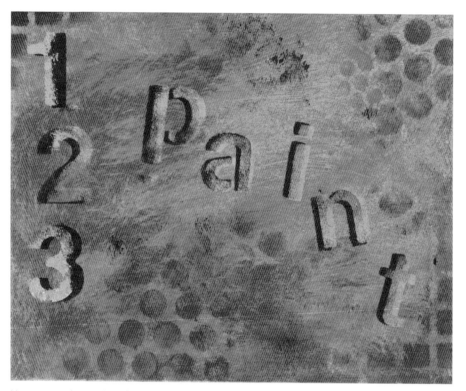

You can use this method for both purchased and found, repurposed stencils.

Artist Tip

Before throwing away packaging from items you purchase, look at them carefully to see if parts can be used for stencils or stamps. You may be surprised!

Letters & Numbers

Letter and number stencils are available in many sizes and font styles and can be used in a variety of ways. Using acrylic paint may be most common, but here are a few other ways:

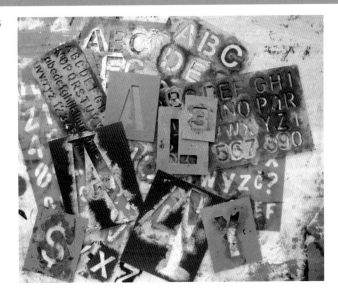

- **Glue Stick Resist** Rub the glue thickly into the stencil opening, and let dry. Then rub over the glue with an inkpad or your brush with a light acrylic wash. Blot the surface with a paper towel to remove excess color from the glue.

- **Acrylic Medium or Gel Resist** Use the bouncing technique to apply the medium through the stencil. Once dry, apply the color wash and blot excess from medium.

- **Mr. Clean® Magic Eraser®** Paint your substrate first and, while still wet, blot the paint through the stencil with the dampened eraser, pressing firmly to remove, or "erase," the paint.

Repurposed Items as Stencils

The number of items used for this technique can be limitless. Paper doilies, open-work plastic place mats, produce bags, fruit baskets, drywall tape—anything with an open-work design can be used!

Cut items into small sections and flatten for stenciling. Using the bouncing technique, paint through the openings to create interesting background designs.

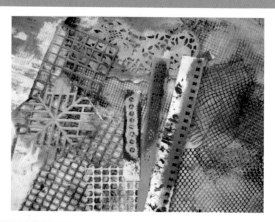

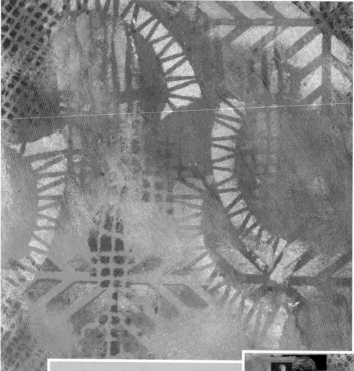

Artist Tip
Many of your repurposed stencil materials can also be used as collage material!

Purchased Stencils & Punchanella

Using a mix of stencils or parts of stencils and punchanella, you can create design and textural effects for your backgrounds. Use the drybrush bouncing technique, color mixing, and repetition of patterns to create visual interest.

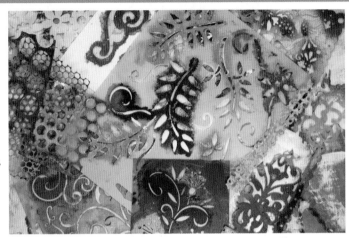

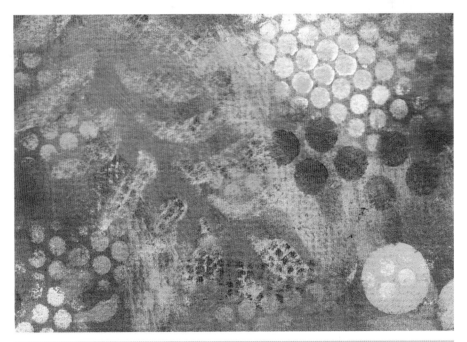

Artist Tip

Punchanella stencils are made from the material that's left over when sequins are punched out of a plastic sheet. You can make your own, or they can be purchased at most art-and-craft stores or online.

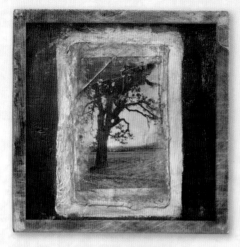

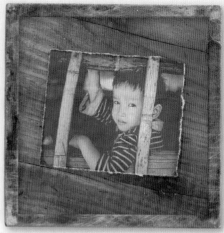

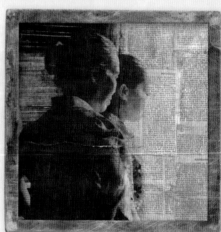

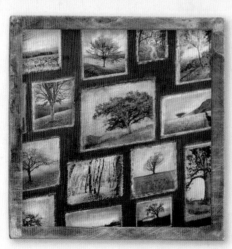

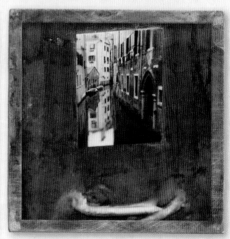

Altering Photographs

with Isaac Anderson

Mixed media photography is the process of taking digital or film images and transforming them through the skillful application of additional mediums. These mixed media photographs might employ the layering of ink, dyes, paint, wax, glue, collage, wood, fabric, metal, and more. The process can be as simple as aging a photograph with tea, and as complex as a multilayered, mixed media masterpiece that would be at home in a gallery or museum!

Materials

- Digital photographs
- Photo-editing software
- Wood or tree branch
- Chop or hand saw
- Reclaimed wood
- Archival glue
- Clear matte finish
- Inkjet printer and paper
- Inkjet canvas
- Clear, UV-resistant coating
- Recycled paper, such as paper grocery bags
- Low-sheen photo paper (optional)
- Acrylic paints (yellow ochre, burnt umber, burnt sienna, black)
- Acrylic gel medium
- Old book or journal
- Old papers (books, newspapers, magazines, etc.)
- Fine-grit sandpaper
- Photographs or scans of various textures

Old Instant Film

Turn your digitally captured images into nostalgic, "Polaroid-esque" memories. Go through an old photo album and look at some of the Polaroids and point-and-shoot photos to get inspired!

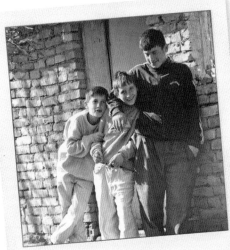

Step One Select the images you think worthy of the instant-photograph feel. Then create the look by adjusting the color, saturation, and contrast of your image in the photo-editing software of your choice. In these examples I have desaturated the colors, added warm yellow tones, and reduced the contrast. All of these elements create a faded, aged appearance.

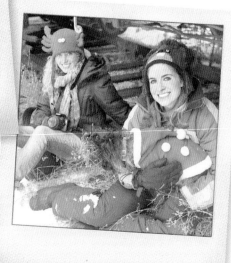

You can create the classic "instant camera" border either by downloading a free template online or simply printing your image on thick photo paper and cutting around it, leaving room for a standard "Polaroid" border on all four sides.

Note: I used Adobe Photoshop® to adjust these images, but there are many free photo-editing applications available for PC and Mac, as well as smartphones! You can achieve limitless effects, and many are as easy as clicking one button for a specific preset look.

Artist Tip

Polaroids were often not the most artistic photos, but they captured the moment in a way only a Polaroid could. Go out and do the same thing—go capture the moment, in a way only an instant camera could.

Family Tree

Try creating a handmade display worthy of your custom instant-camera image!

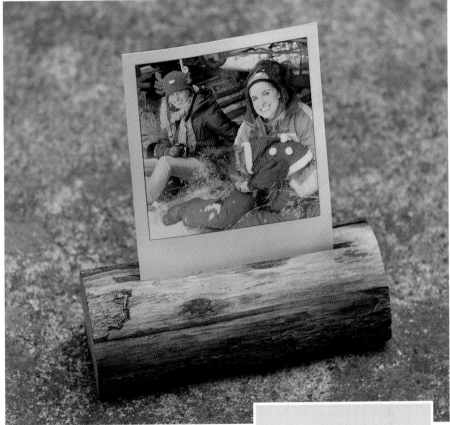

Step One Find a piece of wood or a tree branch that is at least two inches wider than the horizontal width of your Polaroid.

Step Two Cut a ½-inch deep groove into the wood for your Polaroid to sit in. You can use a chop saw or hand saw—this may require some patience as you create a narrow groove to support your image. If you use a tree branch you might need to flatten the base so it will sit on a table or shelf.

Artist Tip
If your photo does not stand upright in your piece of wood, glue it to a stiffer piece of backing paper, or simply wedge a little piece of paper or wood in the groove behind your image to help support it.

Artist Tip
You can also place two photos back-to-back, if you'd like a two-sided photo block. If you want more of the bottom border to show above your groove, cut a larger border around the base of your image. Make as many as you like to create your very own family tree!

Reclaimed Photos

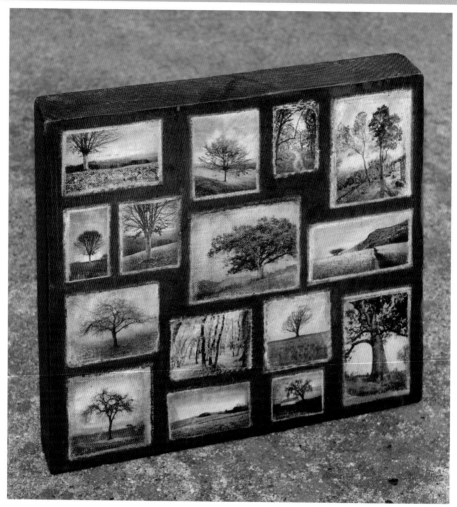

Step One Go through your old photos or digital test prints and find images (or portions of images) that fit a specific theme, such as "trees." Crop your images, focusing on the portion of the photo that relates to the theme.

Step Two Find a reclaimed piece of wood with a solid, flat surface worthy of displaying your photos. Arrange your photos and use archival glue to place the images on the wood. You can apply a clear matte or low-sheen clear finish over the panel to protect your reclaimed work of art.

Artist Tip

Keep an eye out for places to find wood you can reclaim. Old pallets are a great material that can be found just about anywhere. Check with local businesses or contractors for pieces. If you live near a beach, weathered wood often drifts to shore!

Color to Black & White

Find a color image that can take on new life as a black-and-white photo. Search through your old albums and scan a print or negative. You can also look over your catalog of digital images, experimenting with photos that will benefit from a monochromatic conversion.

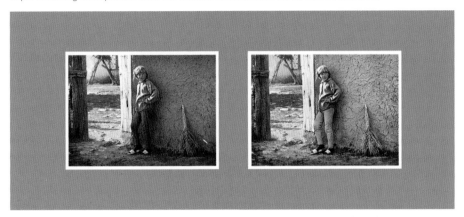

Step One Scan your color print or negative or select a digital photo and bring the color image into your preferred photo-editing application. Then use the image adjustment tool called "Saturation" and take the master color saturation level down to zero. Depending on the program there might be a tool for desaturating your image. Once your image is converted to black and white, adjust the brightness and contrast, maximizing the levels for a high-impact image.

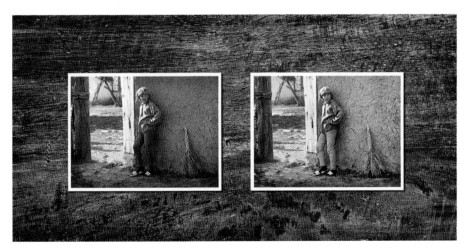

Step Two Print your image on a high quality inkjet paper that is designed to work best with your inkjet printer.

Artist Tip
You might also choose to add a subtle sharpening adjustment to your image if it's lacking clarity, but don't overdo it! You do not want your image to look over-processed or digitally manipulated. The goal is to create a black-and-white image that looks like an old 35mm black-and-white print.

Printing on Canvas

You can purchase specially-coated inkjet canvas designed to work with your inkjet printer. Breathing Color®, Epson®, and HP® are all good sources for inkjet canvas.

Step One Select an image that lends itself to the texture and depth of canvas. Check for specific printing profiles for the brand of canvas and the model of printer you are using. Then print several small test images, making any necessary color, contrast, and saturation changes. If you don't have an inkjet printer, there are many local print shops and online companies that specialize in printing on canvas.

Step Two Once your print is completely dry, coat the canvas with a clear UV-resistant coating designed for use with your canvas. You can frame your image or glue it to a pre-stretched canvas or a flat wooden panel, wrapping the edge of the canvas around the edges of the panel.

Artist Tip

If you have difficulties running the canvas through your printer, you can cut the canvas and carefully tape the edges to a piece of printer paper, leaving a border on the top and sides of the paper. This will allow the printer to more easily grab the paper, pulling it and the attached canvas through the printer without jamming.

Printing on Reclaimed Paper

I took this photo several years ago of a young Burmese boy living in a refugee camp on the Thai-Burma border. When searching through your own photos, look for a high-contrast image that is suitable for black-and-white conversion.

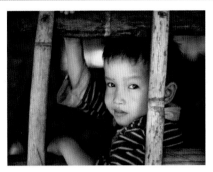

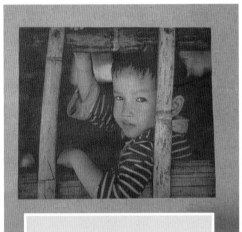

Step One Use your photo-editing software to convert your color image to black and white. Increase the contrast to help the image stand out on the darker-toned recycled paper. Cut or tear a section of paper from a brown paper grocery bag and print your image on your flattened recycled paper.

Artist Tip
Make sure the paper is flat. If it isn't, lightly moisten the paper and iron it on a flat surface before running it through your printer, preferably through the "manual feed" slot if available.

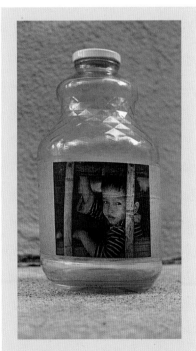

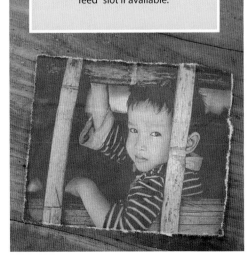

Step Two Cut or tear the paper to "crop" your image, or leave as is and add other art elements to the paper.

Use white glue, wood glue, or archival glue to adhere your printed image on an old glass bottle to create a custom label for your next dinner party or charity event.

Aged Photo

With this technique, the goal is to age the image with subtle, translucent yellow and brown tones. When using acrylic paint you can thin and dilute the paint with an acrylic medium, which will allow you to subtly apply the color without seeing paint strokes or opaque layers of color.

Step One Print your image of choice on canvas or low-sheen photo paper. Then spray or brush on a coat of clear, non-glossy protective finish to seal the print. Let dry completely.

Step Two Brush on a light, thinned coat of yellow ochre—you can dilute acrylic or use reducer to thin oil-based paint to create a light wash. Wipe excess paint off with a cloth so that the image looks like it has been softly yellowed over the years. Repeat the process with burnt umber, using a heavier application of paint toward the edges. Don't use too much paint—you don't want it to look like it's been painted. Repeat again with an extremely light coat of black paint.

Artist Tip
Burnt sienna and raw sienna are two other colors that are great for creating a light, translucent wash. It's typically best to start with your lighter colors first and apply subsequent coats of paint after each layer dries. If the previous coat is not fully dry, your colors are apt to blend and become murky and undefined. Patience—and a good hair dryer—pays off.

Impasto Photo

Step One Select a photograph well-suited for a clear, textured finish that will accentuate the dimensionality of the image. Print your image on inkjet paper or canvas and coat with a water-resistant, clear finish.

Step Two Once the protective coat has thoroughly dried, apply a liberal layer of clear, thick acrylic gel medium. Select several different paintbrushes and brush the clear medium on your print, creating textured brushstrokes as if your photograph were a painting.

Artist Tip
The paintbrushes and acrylic gel medium will make your photograph look more like an oil or acrylic painting. The more detailed you get with your brushstrokes, the more realistic the three-dimensional effect will be.

Book Cover

Find an inspiring image to re-cover an old book or journal, preferably hardcover.

Step One Print your cover image on low-sheen inkjet paper or canvas—the more texture your inkjet medium has the better! Coat your printed image with a clear, low-gloss protective finish or matte acrylic gel. If you like, lightly tint or age the photo with yellow ochre, burnt umber, and burnt sienna paint.

Step Two Once your canvas has fully dried, cut it to wrap around the edges of your book. You can cover the front only or both the front and back. Glue the image to the face and inside of the book cover using archival or white nontoxic glue, duplicating the fold technique used on the original cover.

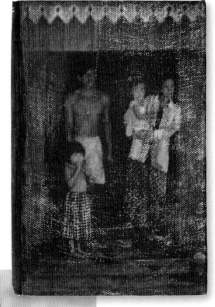

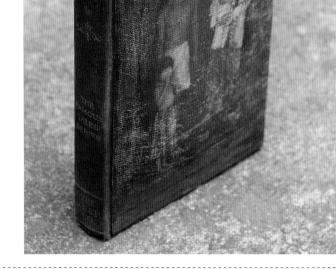

Artist Tip
Once your custom cover is affixed to your book, wipe off any excess glue, and let it dry under a pile of books. This keeps the cover flat and tightly bound while it dries.

Transfer on Wood

For this technique, find a high-contrast image that will stand out on a piece of light-toned wood.

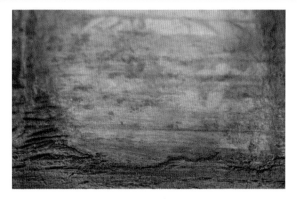

Step One Convert your image to black and white and adjust the contrast, keeping the necessary details of the image, while losing some of the less important detail in the shadows and highlights. This will help the transfer stand out better on the wood.

Step Two When you transfer the photo it will be the reverse of your original photo, so flip the photo in your editing software to create a mirror image and print the flipped image on plain copy paper. Coat both the image and wood liberally with acrylic gel medium and immediately place your image facedown on the wood. Use your fingers or a plastic card to flatten the image and push out any air bubbles. Allow to fully dry, preferably overnight. Brush or sponge room temperature water on the back of your fully dry print and begin to rub the wet paper to slowly peel layers off. Rub until all of the paper has been fully rubbed away, so your image stands out, along with the wood grain and texture beneath.

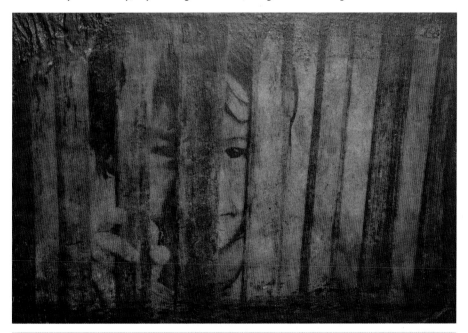

Artist Tip
It's very important that your image be fully dry before you remove the paper, so be extremely patient with the drying time of your acrylic gel medium. Likewise, be very patient and delicate when it comes to rubbing the wetted paper off of your transfer. This step takes some time, but the result is worth the effort!

Collage with Transferred Print Overlay

With this technique, I not only transfer an inkjet print to a panel, but onto a collage of paper from an old encyclopedia.

Artist Tip
Find articles, headlines, or images for your collage that tell a story and, in some way, bring deeper meaning to your printed transfer.

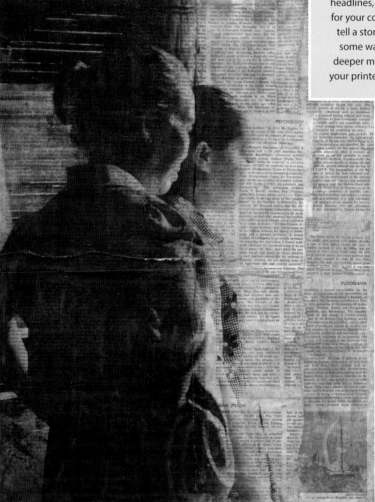

Gather a collection of old paper from books, newspapers, magazines, etc. and glue a collage to a wood or composite panel, using nontoxic white glue. You can paint your collage with a light, translucent coat of acrylic paint if you'd like to further age or tint your prints. Select a high-contrast, thought-provoking image for your transfer. When your collage is dry, coat both the image and collage with acrylic gel medium. Let dry completely and carefully rub away the paper with your fingers, using a sponge or brush to dampen the paper. You may choose to coat your final, completely dry piece with a clear matte or low-sheen protective coat. You can also use your gel medium to add to the texture and depth of the piece.

Distressed Photo on Wood

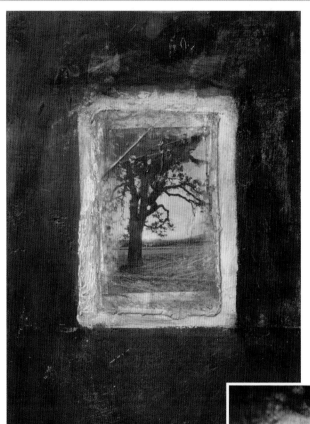

Print a color or black-and-white photograph on low-sheen or matte inkjet photo paper. Brush or spray your image with a coat of clear, low-sheen, protective spray. Once dry, begin to distress your image, using fine-grit sandpaper. You can fold and sand the edges and lightly sand portions of the image. Brush on a light coat of diluted earth-toned paint to age and further distress your image. Wipe off any excess paint, so that it creates a translucent tint on your photo. Reapply a clear protective coating or thin coat of acrylic gel medium (preferably matte). Use archival or nontoxic white glue to affix your photograph to a distressed and aged wood panel.

Artist Tip

You can get creative with your wood panel, hand distressing it and adding paint and aging techniques that you applied to your photograph. You can also add several hooks to your wood panel, making this an ideal key hanger or jewelry holder.

Film Grain on a Digital Image

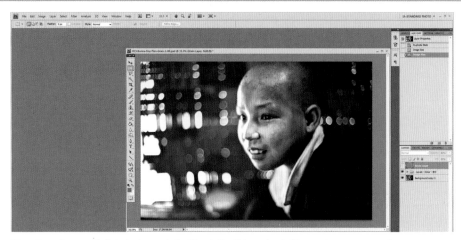

Step One Open a digital photograph that lends itself to a classic film-grain appearance in your favorite photo-editing program. Create a new layer above your photograph layer and fill it with a solid middle-gray color, such as #777777. The lightness or darkness of the gray will affect the intensity of the effect.

▲ **Step Two** Under filters, select "noise" or "grain" and apply to your gray layer. Depending on the application you're using, you may or may not be able to adjust the amount of noise to your liking. You may choose to add a "blur" filter to your noise layer to enlarge or very subtly soften your grain pattern to look like various speeds of film stock.

▶ **Step Three** Select your gray film grain layer, and under "Layer Style", select "Blend" or "Blending Options" and choose "Overlay" for your blending mode. Adjust the opacity or transparency of your film grain layer between 20-100%, depending on the amount of grain you would like to apply.

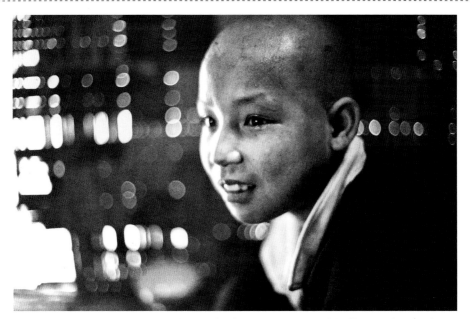

Step Four Selecting the levels tool, adjust the brightness and contrast of the film grain layer until you achieve the perfect level of grain in the highlights and shadows of your image.

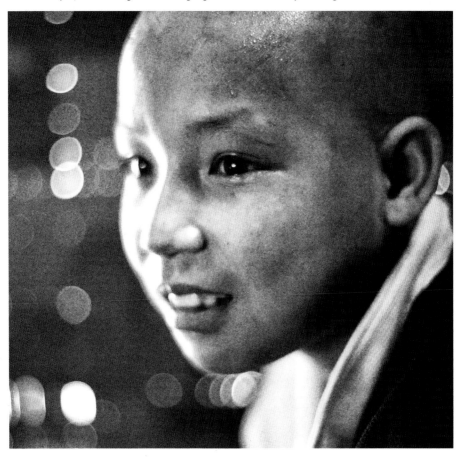

Textured Layers on Digital Images

Step One Open your photograph and several textures in your photo-editing software and create a new layer above your photograph.

Step Two Copy and paste one or more of your textures, creating a new layer for each that sits above your photograph layer. Select your texture layer and, under your "Layer Style" option, select "Blend" or "Blending Options" and "Overlay" for the blending mode. Adjust the opacity or transparency of your texture layer between 10-100%, depending on the amount of texture you want to apply. Adjust the brightness and contrast levels according to your style.

You can use multiple textures on top of your image layer and, using your dodge and burn tools as well as your eraser and lasso tools, you can add texture to specific regions of your photograph.

 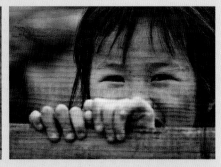

Wood

 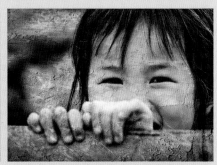

Plaster

 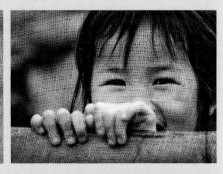

Burlap

 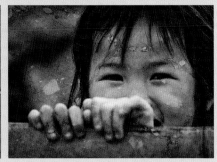

Cracked Dirt

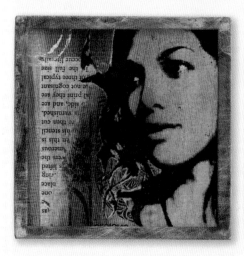
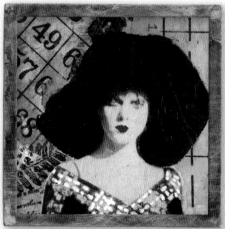

Transferring

with Cherril Doty & Suzette Rosenthal

Combining image transfers with background techniques gives your work depth and interest. There are many ways to transfer images. In this section, we will show you a few of our favorites. We find that transfer results vary according to what is used as a substrate, the weather (if it's dry or damp), and the quality of the image's ink—magazines vary and printers vary. With all image transfer techniques, practice makes perfect. But we like the "happy accidents" that often occur and find they add to the artistic appeal. After your image is transferred, you can use other techniques to enhance and alter it.

Materials

- Several substrates with prepared backgrounds
- Regular printer paper
- Soft-bristled paintbrush
- Acrylic soft gel medium
- Magazine image (not thick pages)
- Laser image
- Inkjet image
- Lazertran™ transfer paper
- Porous paper or other substrate
- Transfer ink (such as Stewart Superior brand)
- Gampi paper or tissue paper
- Old book pages
- Sandpaper
- Spray bottle of water
- Cotton balls
- Baby wipes or damp paper towels
- Bone folder or old credit card
- Blue painter's tape
- Flat pan of water
- Spray fixative
- Acrylic medium (matte)

Magazine Image

When selecting an image from a magazine, keep in mind that the resulting image will be reversed. This is especially important to consider if the image contains text.

Coat your substrate with acrylic soft gel, using a soft-bristled acrylic brush. Use enough gel to adhere the image well, but not too much. Place the image facedown and smooth with a bone folder or credit card, being careful to not get any gel on top of the magazine image. Let dry completely. Then lightly sand and spritz with water before rubbing with your fingers to remove the paper and reveal the image imprint. If there is a gray film, try wiping with baby wipes or a damp paper towel.

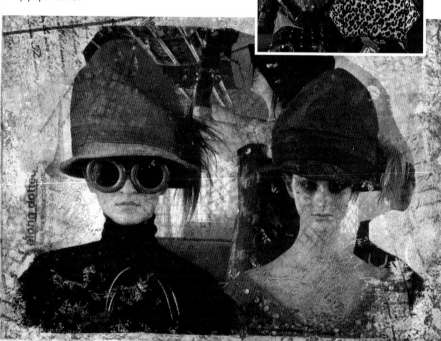

Artist Tip

Lighten areas of your painted substrate with gesso or light color paint where you want the transferred image to go by using one of the various painting techniques. You can also collage with light tissue or other papers to create a lighter area.

Laser Printer Image

Print your selected image on a laser printer. Apply acrylic soft gel on your substrate. Then lay the image facedown, smooth, and let dry. Once dry, sand lightly and spritz with water before rubbing with your fingers to remove the paper backing.

Artist Tip
If you do not have a laser printer, you can get laser copies made at your local printer. If you want the exact image, make sure they reverse the copy!

This transfer is a straight laser copy of a magazine image.

This transfer is an altered laser copy of a magazine image.

Here you can see the original magazine image and three variations using hue, saturation, posterization, and other Photoshop adjustments and filters.

Artist Tip
You can use magazine images or your own photos as is. However, you can get a more artistic feel by using computer programs such as Photoshop or Picasa® to experiment with filters and other photo-altering techniques.

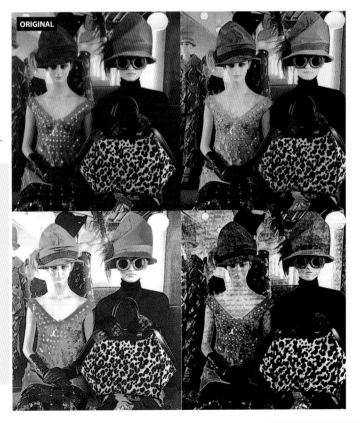

ORIGINAL

Inkjet Printer Image

The availability of inkjet printers makes this an easy technique to try, but it can also be tricky. Timing is everything. Factors such as the weather or other conditions will influence the results.

Paint a layer of soft gel on your substrate and place the inkjet image face down. Smooth the image with the credit card or bone folder and rub with your fingers, using medium pressure. Slowly peel the paper back. If the image is transferring, continue. If not, rub and repeat. When you use this method do not allow the gel to dry before peeling off the paper.

Artist Tip
Set your inkjet printer on "high quality" or "fine" printing for best images.

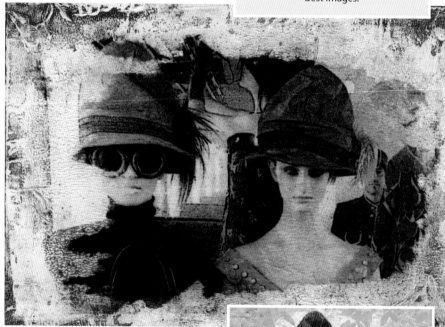

Multiple Inkjet Transfers
Try combining multiple inkjet transfers and adding color. Use stencils to add movement and texture.

Lazertran™ Transfer

Lazertran™ is a water-slide decal—it sits on the top of your substrate. Because of this, it is not as transparent as the other techniques. Go to www.lazertran.com for available sources of the transfer paper.

Step One
Follow the packaging instructions that tell you how to print an image on your type of printer. Once the image is printed, cut to size and soak in a flat pan of water until the image releases from the backing.

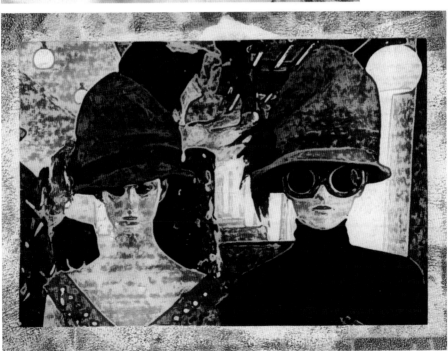

Step Two Blot dry with a paper towel. Then apply soft gel to your substrate and the image, and coat with gel on top.

Printing on Gampi or Tissue Paper

Japanese Gampi paper is strong, thin, and translucent, with a silky quality. You can find it in varying weights and colors.

Step One Both Gampi and tissue paper will give you a transparent image to adhere to your substrate. To print, cut the paper at least one inch smaller than standard 8 ½" x 11" printer paper. Adhere to the printer paper using blue painter's tape, at least one inch from the edge in order to avoid a paper jam. Do not use the high speed setting for this technique, as too much ink oversaturates the image.

Step Two Print your image, and then spray it with spray fixative. Adhere to your substrate using acrylic medium.

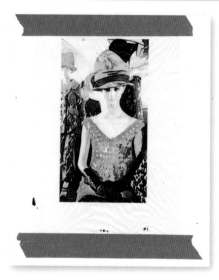

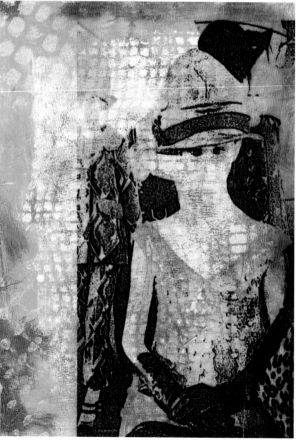

Experiment with combining techniques for fun pieces! In this example we applied a magazine transfer over stamped tissue and an inkjet image.

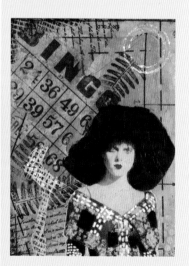

Transfer Ink Images

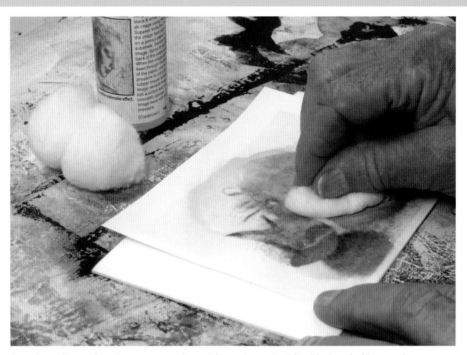

Step One On regular printer paper, make an inkjet printout in either black and white or color. Place the image facedown on porous paper or another porous substrate, not on a painted background. Spray the transfer ink to evenly wet the paper. When you can see the image clearly, rub or dab a cotton ball over the surface with even pressure to transfer the image.

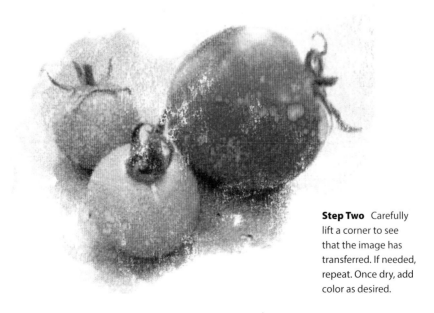

Step Two Carefully lift a corner to see that the image has transferred. If needed, repeat. Once dry, add color as desired.

Polymer Skins

This technique is achieved over several days and can be used with magazine, laser, or inkjet images.

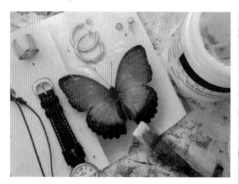

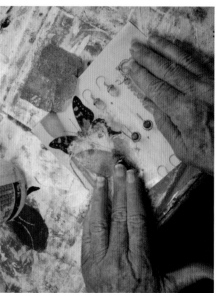

▲ **Step One** With your acrylic brush, coat the front of the image with soft gel. Let dry. Repeat multiple times in order to form a thick "skin."

▶ **Step Two** When all layers are dry place the image facedown, sand the back lightly, spritz with water, and rub the paper backing off.

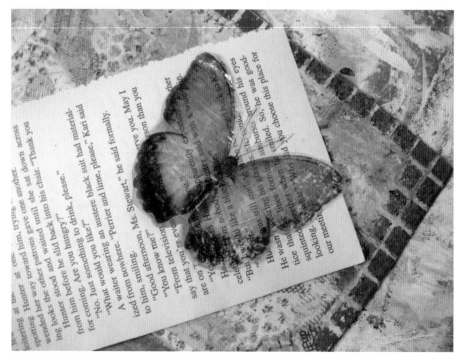

Step Three This creates a somewhat see-through image, which can be adhered to any painted substrate. You may need to trim excess away from your image.

Book Page Transfer

With this technique, keep in mind that the image will be reversed. You can sometimes find old books with images and print combined. We like the look of the reversed words, though some may not. The basic technique is the same as for transferring magazine images.

Step One Coat the substrate with soft gel, place the image facedown, rub, and let dry.

Step Two
When dry, lightly sand and spritz with water before rubbing off paper backing. You can leave some areas of the backside intact for added visual interest.

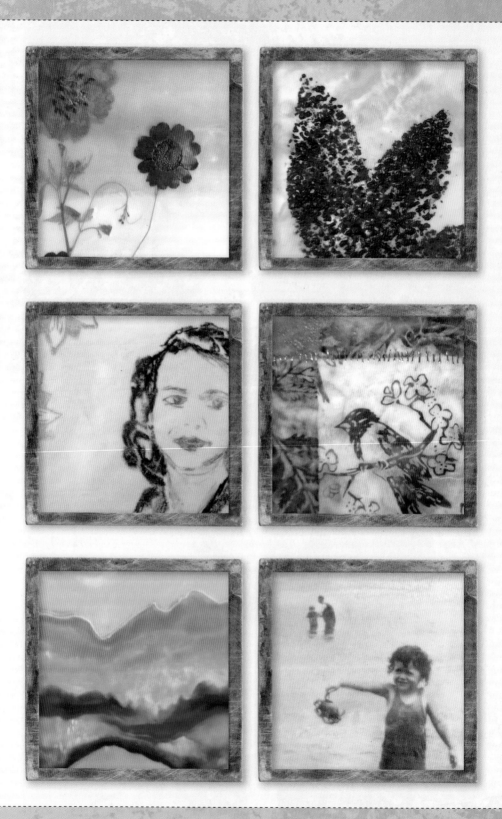

Encaustics

with Linda Robertson Womack

Encaustic is a versatile and forgiving medium, allowing you to "undo" almost anything. It's the process of painting with a mixture of beeswax, resin, and pigment to make paintings or collage with wax instead of glue. Encaustic is compatible with most types of media. You can buy commercial encaustic paints in many colors and thin them with any amount of clear encaustic medium to get the consistency you want and to extend your paint. Simply heat your paint in tins or directly on a pancake griddle at about 200° Fahrenheit and use natural-bristle brushes—synthetic will melt. After you paint on each layer of wax, it must be fused with heat so that it bonds to the layer beneath—usually with a heat gun or a torch. Consider combining several of these techniques to find your own unique look and don't be afraid to experiment!

Materials

- Encaustic paints in various colors
- Natural-bristle brushes
- Heat gun or torch
- Stylus (optional)
- Photographs
- Heavy card stock
- Archival glue
- Clear encaustic medium
- Oil or chalk pastels
- Dried plants
- Stencil (optional)
- Scraper
- Various papers, fabric, or felt
- Scissors
- Heat transfer foil
- Tracing paper
- Charcoal, graphite, or pastels
- Rubber stamp
- Lace (optional)
- Hobby iron

Go with the Flow

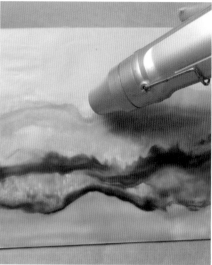

Step One Paint stripes using four to five different colors of encaustic paint. Overlap your stripes a little when painting to create secondary colors.

Step Two Fuse the stripes with a heat gun while moving around on the board until you create a "landscape."

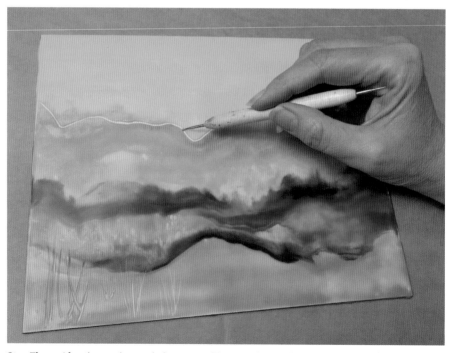

Step Three After the wax has cooled you can add more color and fuse again or use a stylus or dull pencil to carve lines into the wax.

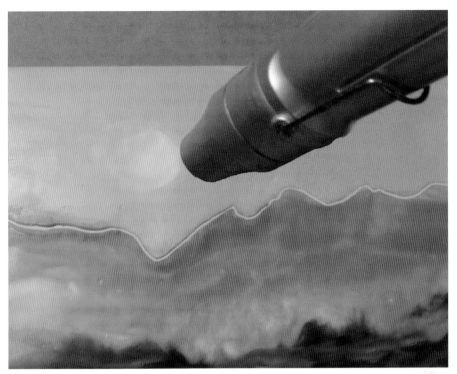

Step Four Use the heat gun to blow a "hole" in the wax to create a sun or moon in your landscape.

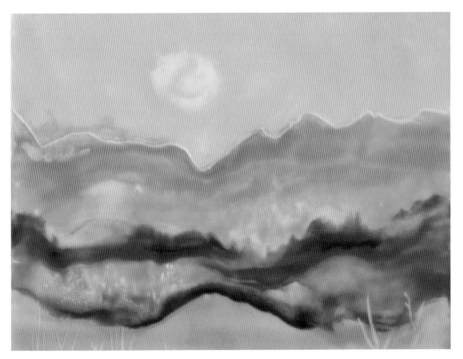

This technique helps beginners get a good feel for working with wax. Try using it to suggest tree branches, reflections on water, or other organic shapes.

Capture a Memory

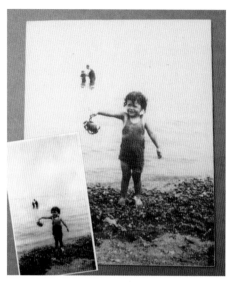 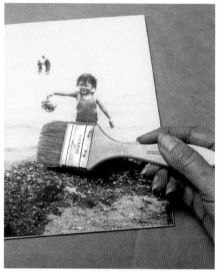

Step One Glue a black-and-white photocopy printed on heavy card stock onto a smooth, rigid board, using archival glue.

Step Two After the glue dries cover the photograph with clear encaustic medium.

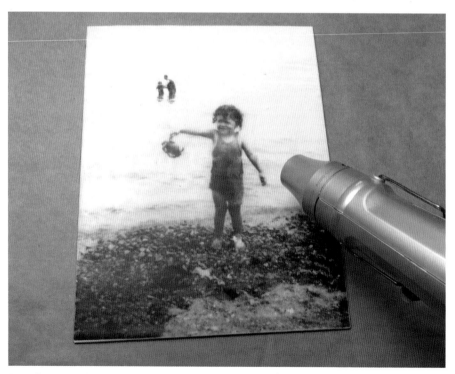

Step Three Fuse the wax with a heat gun. You may have to add more than one layer of medium to get an even coat.

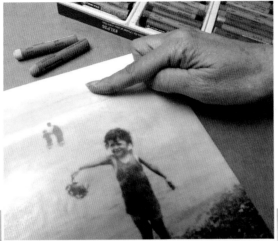

Step Four Hand-color the photograph by rubbing oil or chalk pastel onto the surface of the wax. Heat it briefly to bond it with the wax.

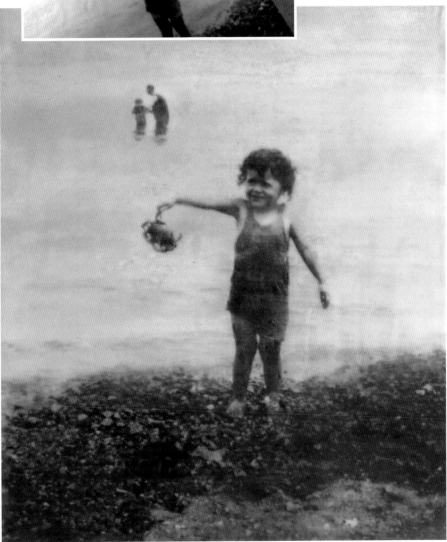

This family photograph of my mother at Renee Beach in Massachusetts now has a fun, contemporary look.

Wish Garden

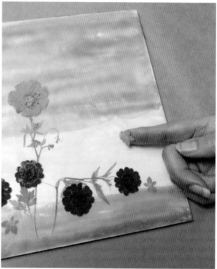

Step One Paint a background with a few colors of encaustic paint and fuse it with a heat gun.

Step Two While the wax is still warm gently press dried plants into the surface to make your design.

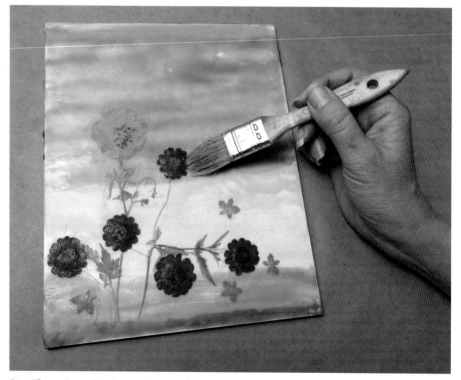

Step Three Cover the plants with a very thin layer of encaustic medium and fuse lightly with a heat gun.

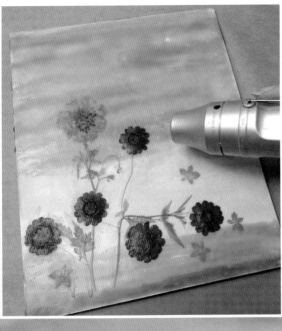

Step Four Add more layers of encaustic paint or dried plants until you get the look you want.

Artist Tip
Don't be afraid to bury some of your plants with encaustic paint and leave others more visible to create depth.

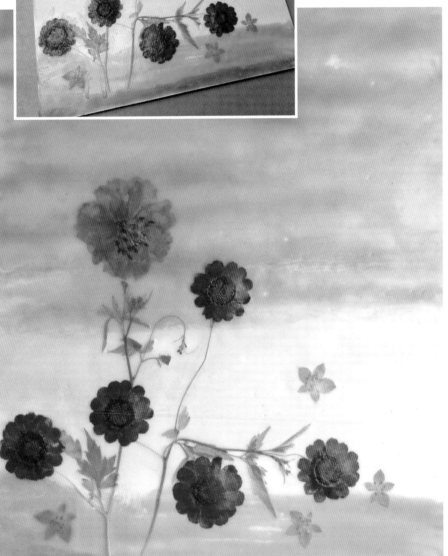

I call this a "wish garden" because I wish my backyard gardening were this easy—no weeding necessary!

What Lies Beneath

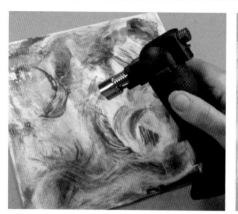

Step One For your first layer swirl a few colors of encaustic paint and fuse them. A crème brûlée torch is a great alternative to a heat gun for fusing. Just touch the flame to the surface of your wax.

Step Two Add a second layer with different colors and fuse. You can repeat this step as many times as you like.

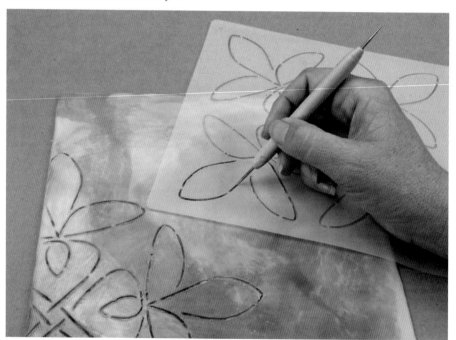

Step Three Use a stylus to carve into the layers of wax to reveal the colors on previous layers. You can use a stencil or carve freehand.

Artist Tip
Use mostly dark colors on the bottom layer and lighter colors on the top (or the other way around) for better contrast in your final painting.

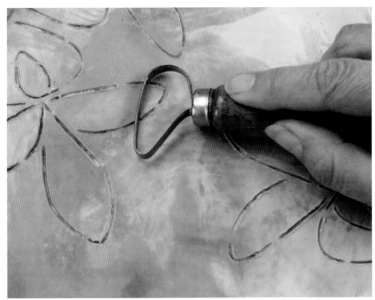

Step Four

Remove any raised wax you don't like with a scraper. This takes patience, so skip this step if you don't feel you need it!

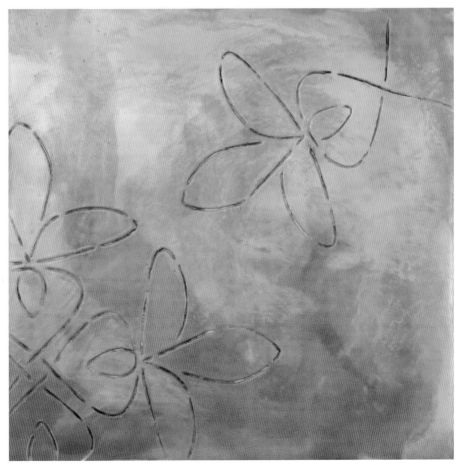

In just a few steps you can make an elegant painting using very simple techniques.

Wax Quilt

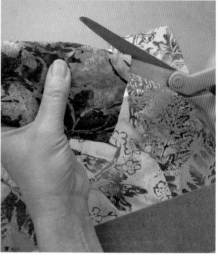

Step One Paint encaustic medium on your board and fuse it with heat.

Step Two Cut and lay out the pattern of your quilt using paper, fabric, or felt. Cut the materials slightly larger than you need in case they shrink a bit with the wax and heat.

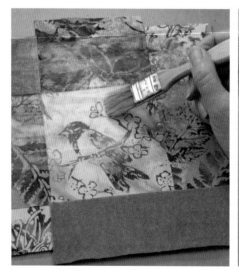

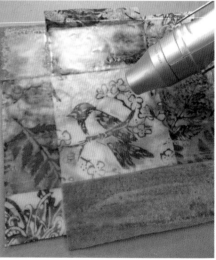

Step Three Carefully cover the materials, trying not to move anything, with as thin a layer of encaustic medium as you can.

Step Four Fuse the wax to hold your quilt in place. It will be milky when hot but should turn clear when it cools.

Artist Tip
If your wax is still milky after it cools, just scrape some of it off until it's clear and heat it gently to remove the tool marks. You can use the same technique to remove foil stitches.

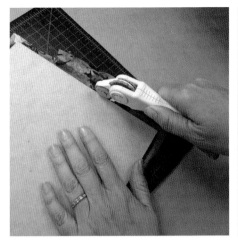

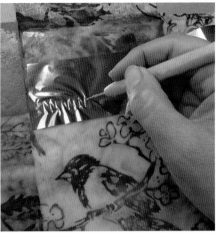

Step Five When the wax is cool, flip the panel over and trim the edges of your board.

Step Six Add "stitching" with heat transfer foil in your favorite color by using a stylus or dull pencil to draw lines on the foil, which will transfer it to the wax.

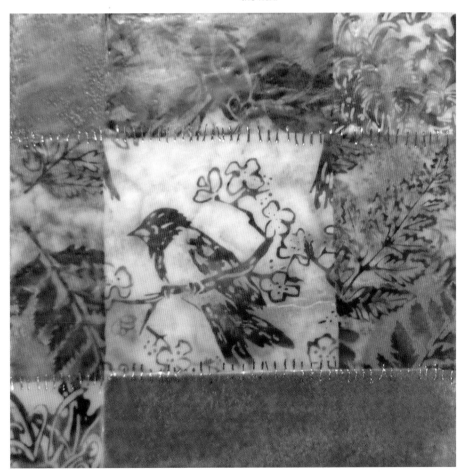

When you're done, you have a quick, easy quilt—no sewing required!

Trace a Face

In this technique I use tracing paper to trace a photograph with charcoal and transfer the drawing directly onto warm wax.

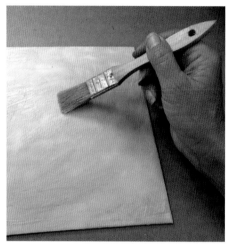

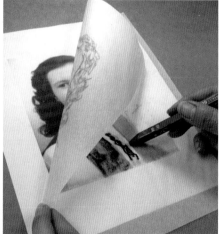

Step One Use light colors of encaustic paint to create a muted background; then fuse it as flat as possible.

Step Two Place tracing paper over a photograph and trace the image using charcoal, graphite, or pastels.

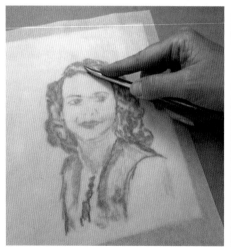

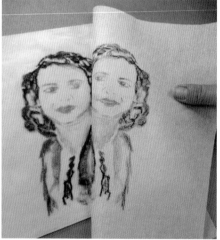

Step Three Place the tracing facedown on your wax background and burnish, or rub gently, to transfer your drawing.

Step Four Carefully pull the paper up to check your progress and see where you need to burnish more.

Artist Tip

Remember that image transfers come out as a mirror image. Plan accordingly for your composition and background. You'll need to trace text backward for it to come out readable on the final painting.

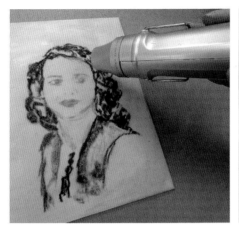

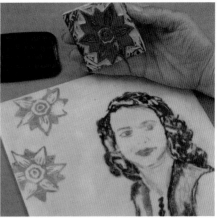

Step Five Before you do anything else, fuse the image into the wax background! If you forget this step the image may smear. Seal the image with a layer of encaustic medium and gently fuse.

Step Six You can also rubber stamp directly onto cool wax to add more interest to your painting. This is a stamp I carved myself, but most commercial stamps will work too.

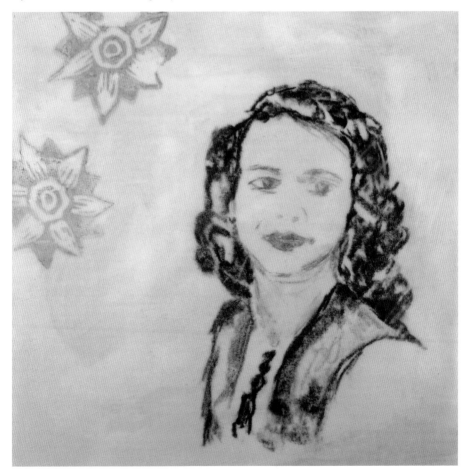

Even if you don't think you can draw, you can make an engaging portrait, or any other type of image. Just trace it to make it your own!

Tons of Texture

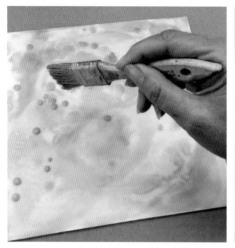

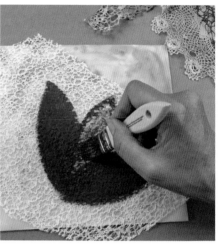

Step One Create an interesting background by varying your paint strokes. Try dripping and scuffing the brush in several directions. Then fuse.

Step Two Brush encaustic paint through lace or fabric with an open weave. Don't worry if every hole isn't filled.

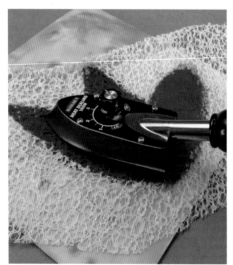

Step Three Use a hobby iron to melt the wax through the material, filling in any holes you missed. Let the paint cool completely.

Step Four Gently heat just the surface of the wax to release it from the material. Then pull it back gently to reveal a textured pattern.

Artist Tip

If paint comes up when you pull the material, it wasn't cool enough. Iron it back down and try again when it's completely cool.

Step Five The pattern will be fused flat from the iron, but you can also use a heat gun to bead up wax for maximum effect. The choice is yours!

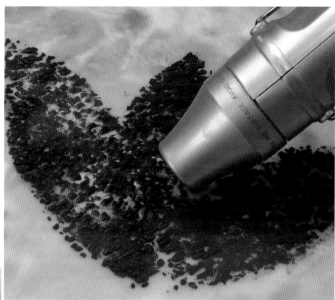

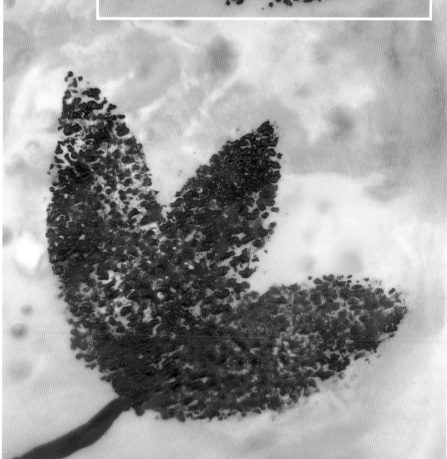

Step Six Sometimes I like to add or remove wax to strengthen the composition. Here I've added a simple stroke to suggest the stem of a flower.

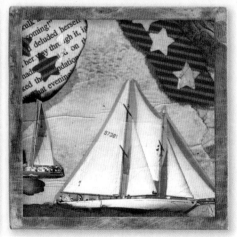

Playing with Paper

with Cherril Doty & Suzette Rosenthal

There are myriad ways to play with paper in creating your artwork. Paper may provide you with just a background or supply focal points for the work. Papers might create a picture out of various elements or make a new picture out of several disparate ones. The key for us is in the "play." In this section we will show you just a few of the ways you might have fun with papers in your art pieces.

Materials

- Variety of papers
- Soft acrylic brushes
- Acrylic medium (matte)
- Masking tape
- Scissors
- Rubber stamps
- Acrylic paint
- Pens (waterproof, permanent)
- Inkpads (waterproof, permanent)
- Paper punches
- Spray bottle of water

Paper Sources

Here are some good sources to get started with your paper collection. Be open to all the possibilities for paper ephemera beyond these basics!

▶ Magazines and catalogs

◀ Recycled papers, such as newspapers (including foreign language papers), security envelopes, old books and maps, old letters or papers, phone books

▶ Purchased papers, such as scrapbook and other specialty papers, origami papers, gift wrap, art papers

◀ Transparent papers, such as tissue (printed and solid), sewing pattern paper, napkins (printed and solid), rice papers

How to Glue Paper

Use acrylic matte medium on a soft acrylic brush to adhere papers to your substrate. You may also use the medium over the surface of your work, as it will dry clear. With magazine images, it is helpful to spritz them lightly with water to limit wrinkling as you adhere them. For heavy papers, use an acrylic gel in the same manner.

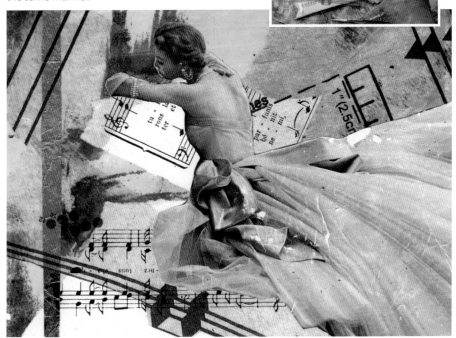

Handling Paper

There are many ways to use paper besides just adhering it straight to your substrate. Try some of these, and see what else you can come up with.

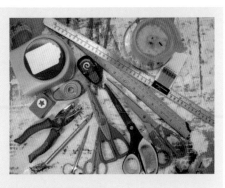

• Cutting—Cut with regular scissors or those with specialty edges for interesting effects.
• Tearing—Roughly tear papers or tear along a metal straight edge. White edges of torn magazines will absorb paint. Tear in different directions for different effects.
• Punching—Use paper punches to create holes or designs in your papers.
• Burning—Burn the edges of papers lightly with a match or candle flame or scorch in the oven. Keep a tray of water nearby just in case.
• Wrinkling—Crumple papers and smooth them before adhering to create a crinkly or vintage appearance.

Paper as an Underlayer

Tear up and mix security envelopes to create a high-contrast background for your work. Other torn papers, such as book pages, can also be used in this manner.

Sections of newspaper, phone book pages, maps, sheet music, etc. can be adhered over the entire substrate and painted with a light wash for a background or underlayer.

Masking Tape Peel

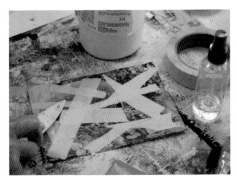

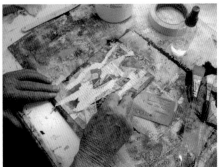

Step One Adhere papers to your substrate using acrylic matte medium under the papers only. Medium on the surface will interfere with the process. While still damp, place strips of masking tape on top in a random fashion. Press the tape down with the edge of a spoon, old credit card, or bone folder. Let dry.

Step Two Remove the tape. You may want to save the tape pieces for use in another collage piece.

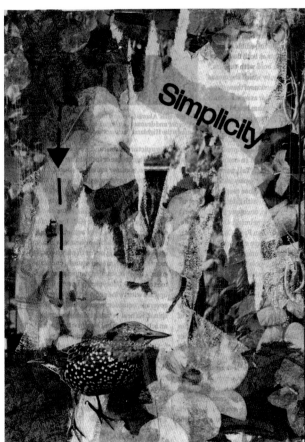

Step Three Using paint, papers, washes, images, etc., create your piece over this interesting background.

Layering Transparent Papers

Transparent papers, such as tissues, sewing pattern paper, or napkins, can be used like a layer of paint or a wash. Colored images over a printed background add dimension.

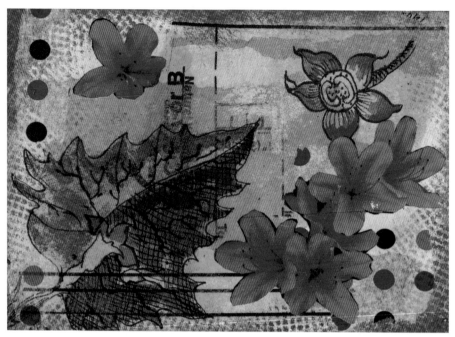

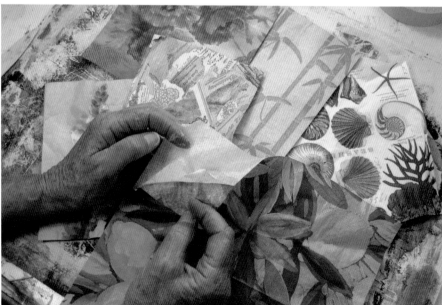

To separate the layers of a two- or three-ply napkin first make a small tear at the edge. Then gently separate the layers. All layers are useful! Set aside the middle and bottom layers for stamping. These pieces can also be used as layers in your creation.

Stamping, Writing & Stenciling

Use transparent layers such as tissue papers, sewing pattern paper, and transparent art papers like rice paper. You can also use the layers you've saved from napkins.

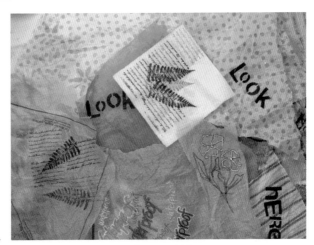

Stamp or stencil on these papers using acrylic paints or waterproof inkpads. When writing, make sure to use a permanent, waterproof pen, available at any art supply store.

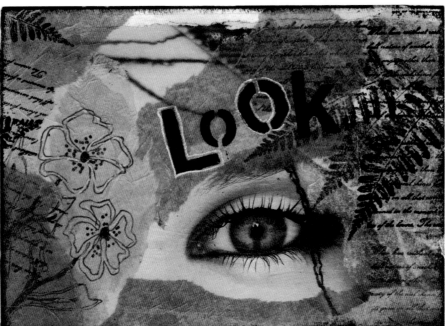

These pieces can be used whole over an entire piece or torn and used as accents or collage elements.

Artist Tip
It's fun to have an assortment of waterproof pens in various colors and sizes on hand. You can accent your work with outlines, words, drawings, squiggles, etc.

Rule of Three

This technique is an easy-to-remember compositional gambit. The three elements used are: a focal image, a piece of patterned paper (such as a torn segment of scrapbook paper), and a torn piece of napkin or tissue.

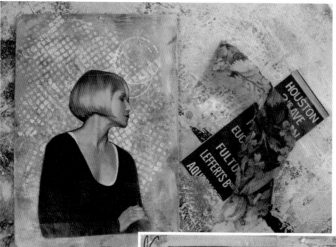

Combine the three elements on a painted substrate, slightly off-center. The use of the other two elements with the focal image helps it blend into the piece more cohesively than just placing the image on the background alone.

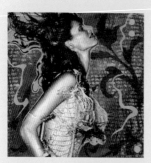

Artist Tip

When cutting images, save the cut-away pieces and use them to add color and interest to your work. The viewer's eye likes to follow the repeated line.

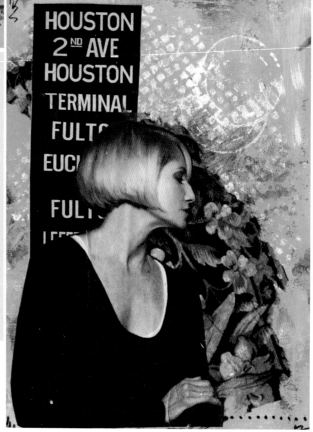

Painting with Paper

"Painting" with paper can be either abstract or representational in nature and may be done with any of the available papers.

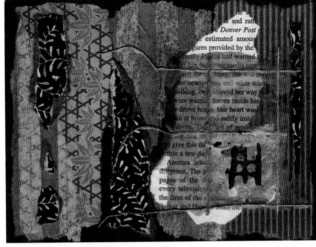

Abstract Use the color, texture, edges, and transparency of the papers to create a visually pleasing design.

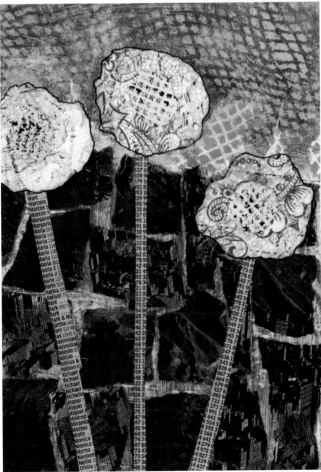

Representational Cut or tear papers to represent an image or images. This can be done over the entire substrate or over just a portion of it. Add highlights with paints, pastels, waterproof pens, etc.

Collaging with Images

It's fun to take images and reassemble them into something either real or surreal and different. You can also add transferred images to the mix!

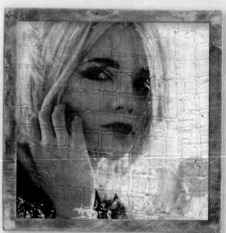

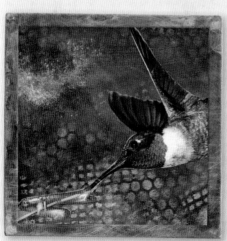

Adding Texture

with Cherril Doty & Suzette Rosenthal

Texture—whether physical or visual—provides variation and relief and adds greater impact and interest to your work. Physical texture is something you can feel by running your fingers over it. It may be a buildup of mediums or a layering of collage or embedded materials. It actually changes the surface. The techniques shown are interchangeable among the gesso, gel, and texture paste methods.

Visual texture is an illusion you can create with the materials you use while the surface remains flat. It can be achieved with paint strokes, dark and light tones, or a vast array of other techniques.

Materials

- Gesso
- Acrylic gel medium
- Texture paste
- Ceramic stucco
- Glass beads in medium
- Putty knives
- Old credit cards
- Rug backing
- Tape rolls
- Plastic fruit baskets
- Cheesecloth/gauze
- Lace
- Drywall tape
- Corrugated cardboard
- Leaves, pods, and other natural elements

Using Gesso

Gesso is an opaque primer that makes surfaces more receptive to paint. To adhere textural elements as an underlayer, first coat the surface with gesso, lay down the textural elements, smooth, and coat again. Add more coats for buildup. Some of the elements you can add are listed here:

- Natural: leaves, seeds and other flat items in nature
- Man-made: cheesecloth or gauze, lace, drywall tape, produce bags, crumpled tissue paper, etc.
- Gesso: drizzle onto the surface to create an interesting textural effect

Drywall Tape

Cheesecloth

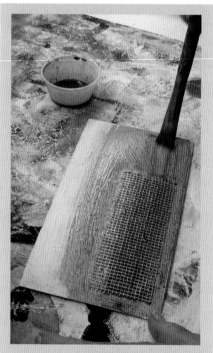

Lace

Artist Tip
A light wash of color may be used over gesso, gel, or texture paste to enhance the textures.

Using Gel Medium

While gel medium is routinely used to adhere heavier-weight elements to a piece, it can also be used to create texture.

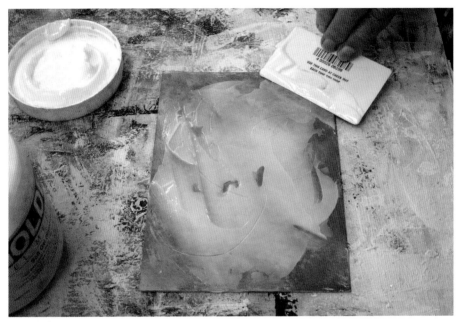

Step One Apply the gel with a brush thickly over the surface. You can then create texture with any of your available tools, such as putty knives, credit cards, tape rolls, forks, etc. Let the gel dry completely.

Step Two The gel dries as a clear coat, so it can be used either as an underlayer or as a top layer.

Adding Visual Texture

The appearance of texture can be added in a variety of ways.

Use acrylic paint to drybrush stipple and stencil through produce bags or drywall tape, and apply light on dark colors to create the look of texture and depth.

With collage you can use images of texture from magazines and specialty papers to create visual texture.

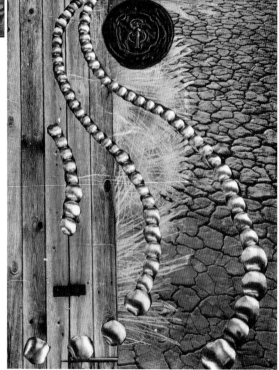

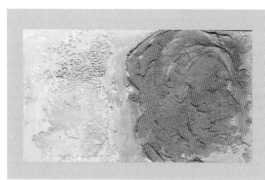

Artist Tip

Spackle and plaster are also good textural materials. You can make marks or embed sand, small beads, and other items in these textures, as with other materials.

Adding Objects

Use cheesecloth, gauze, drywall tape, screening, produce bags, lace, and other materials to add visual texture and interest. To attach these textural items to your piece use acrylic gel under and over them. Add embellishments, such as flat game pieces, keys, feathers, and coins.

Produce bag

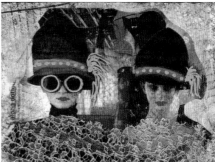

Lace

Coin

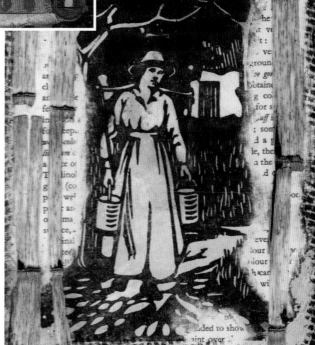

Reeds

About the Artists

Isaac Anderson is a self-taught artist whose passion for photography has taken him on many journeys as a documentary filmmaker. He has spent the last eight years in Southern California experimenting with photography, mixed media painting, and documentary filmmaking. Visit www.isaacandersonart.com to learn more.

Cherril Doty is an artist, writer, and Director of the Sawdust Art Festival's Studio Art Classes in Laguna Beach, California. While she holds a masters degree in counseling psychology, the need to create has called, and Cherril followed her muse to try new forms and search possibilities. Mixed media represents the culmination of the search and is the process by which to achieve still more through teaching and experimentation. Visit www.cherrildoty.com to learn more.

Samantha Kira Harding is an artist by accident, a writer by schooling, and an explorer by birth. Samantha teaches classes on journaling and the artful experiences of daily life, including "True to You," a workshop focusing on every day as fuel for journaling adventures. She has been published in *Somerset Studio, Artful Blogging, Art Journaling*, and *Cloth, Paper, Scissors*. Visit www.journalgirl.com to learn more.

Jennifer McCully is a graphic designer who unleashed her creative spirit to include mixed media work. Her endless creativity can be seen on her bold canvases, which feature vibrant and simple objects that are energetic and inspiring. Her childlike creations evoke happiness, and her inspiration is drawn from practically anything. Jennifer is a full-time Etsy seller, operating four different shops. She is also the author of *There are No Mistakes in Art*. Visit www.jennifermccully.com to learn more.

Suzette Rosenthal is a mixed media and fiber artist who lives and works in Laguna Beach, California. She has exhibited locally at various venues and is a longtime exhibitor at the Sawdust Art & Craft Festival in Laguna Beach. For the past eight years she has taught numerous mixed media classes—six of those years as a teaching team with Cherril Doty. Suzette and Cherril conduct an ongoing Sunday Study Workshop in Laguna Beach, where they have honed their teaching skills and mastery of certain techniques.

Linda Robertson Womack is the author of *Embracing Encaustic: Learning to Paint with Beeswax*. She is often a featured speaker and instructor at national conferences, and her mixed media work has been published in numerous books and periodicals. Linda hosts online classes at www.robertsonworkshops.com, bringing together a community of international artists. Visit www.lindarobertsonarts.com to view her art or receive her free newsletter.